IMAGES
of America

SAN FRANCISCO'S
NOE VALLEY

Jody + Ethan

Congrats on your new

digs

Lisa + Jimmy

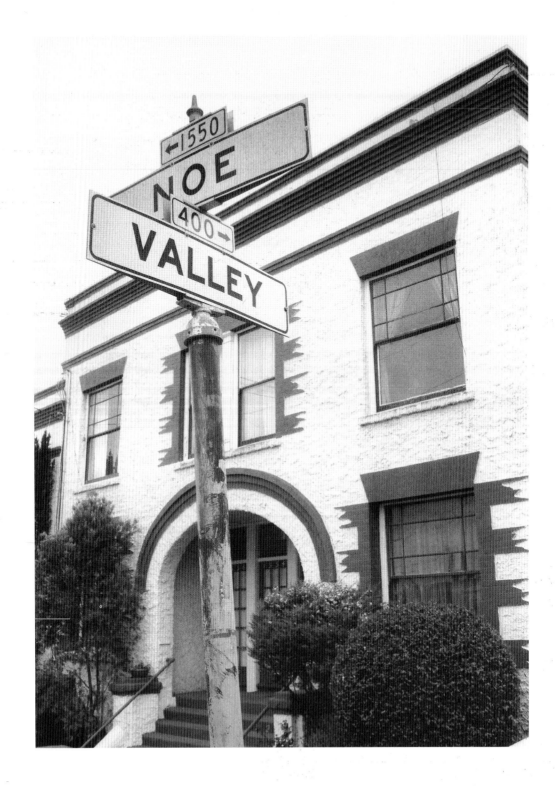

IMAGES
of America

SAN FRANCISCO'S
NOE VALLEY

Bill Yenne

ARCADIA

Published by Arcadia Publishing
Charleston SC, Chicago IL, Portsmouth NH, San Francisco CA

Printed in Great Britain

Library of Congress Catalog Card Number: 2004105265

For all general information contact Arcadia Publishing at:
Telephone 843-853-2070
Fax 843-853-0044
E-mail sales@arcadiapublishing.com
For customer service and orders:
Toll-Free 1-888-313-2665

Visit us on the internet at http://www.arcadiapublishing.com

Please address editorial comments to the author at noevalleybook@netscape.net.

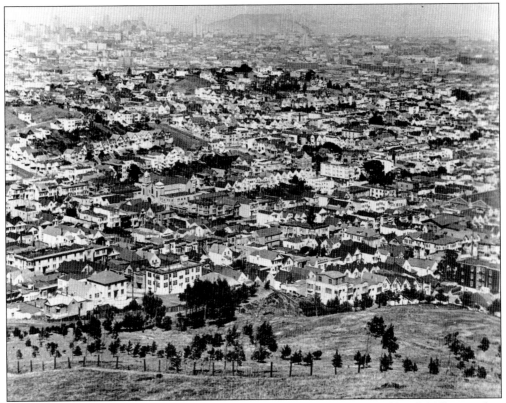

Noe Valley is clearly recognizable in this panoramic view taken from Red Rock Hill—in what is now Diamond Heights—about 1938. St. Philip's Church is visible as is the line of Queen Anne Victorians on Twenty-third Street. (Courtesy of the Noe Valley Archives.)

4

CONTENTS

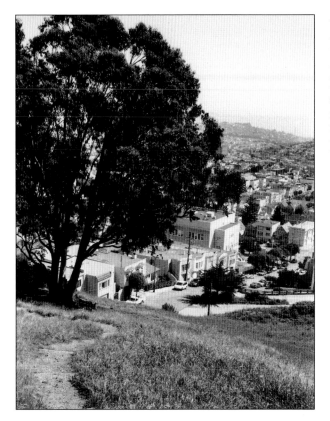

Where the country meets the village . . . This is the view from Billy Goat Hill looking down on the intersection of Thirtieth and Laidley Streets, as it has looked since the 1950s. Although billy goats no longer roam the hill, the northeast slope remains largely undeveloped. (Photo by Bill Yenne.)

ACKNOWLEDGMENTS

The author would like to thank all of his friends in Noe Valley for their help and encouragement with this project. Special thanks are due to Paul Kantus of the Noe Valley Archives for supplying the majority of the photographs that are used in this book and for reviewing the text for historical accuracy. Thanks also to John Garvey, Al Sassus, and Susan Stacks of St. Francis Hook & Ladder for providing information about Noe Valley's fire stations.

ABOUT THE AUTHOR

Bill Yenne is the author of more than three dozen books on historical topics, as well as many large-format pictorial books for American and international publishers, including the acclaimed *San Francisco Then & Now*. He is a member of the San Francisco Aeronautical Society, the American Aviation Historical Society, and the American Society of Journalists and Authors. He is a graduate of the Stanford University Professional Publishing Course.

Mr. Yenne and his wife, Carol, have owned a home in Noe Valley for three decades and they raised both of their children, Azia and Annalisa, in Noe Valley. Carol owns Small Frys Children's Store on Twenty-fourth Street and is an active member of the Noe Valley Merchants' Association.

INTRODUCTION

In the heart of San Francisco, there is a quiet residential neighborhood that has earned a reputation for being a "village within the city." A traditional working-class neighborhood, it gradually evolved into a highly desirable residential area for people who sought to have the amenities of a smaller village without having to leave the confines of the city. By the beginning of the 21st century, it was seen as being one of the two or three most desirable residential areas within the city.

Located in the geographical center of the City and County of San Francisco, the district is in the valley formed by Glen Park to the south, Diamond Heights to the southwest, Twin Peaks to the west, and by the line of hills that include Alvarado Heights and Dolores Heights to the north. The generally accepted boundaries of Noe Valley are Grand View Avenue on the west, Twenty-first Street on the north, Dolores Street on the east, and Thirtieth Street on the south.

At the northeast corner of Noe Valley is the section bounded by Twentieth, Twenty-second, Dolores, and Mission Streets that was designated in 1985 by the San Francisco Landmarks Preservation Advisory Board as the Liberty Hill Historic District.

The other adjacent neighborhoods include Twin Peaks to the west, Eureka Valley to the north, Glen Park to the south, and the Mission District to the east. Indeed, Noe Valley was long considered a sub-section of the Mission District. Both shared the old "Mission" telephone exchange, evidence of which is seen in the numerous "64-prefix" telephone numbers that still exist throughout both the Mission District and Noe Valley.

The heart of Noe Valley is the shopping district that extends along Twenty-fourth Street from Douglass Street to Church Street, mainly in the blocks between Castro and Church Streets. An additional, smaller shopping district is located on Church Street between Twenty-seventh Street and Thirtieth Street.

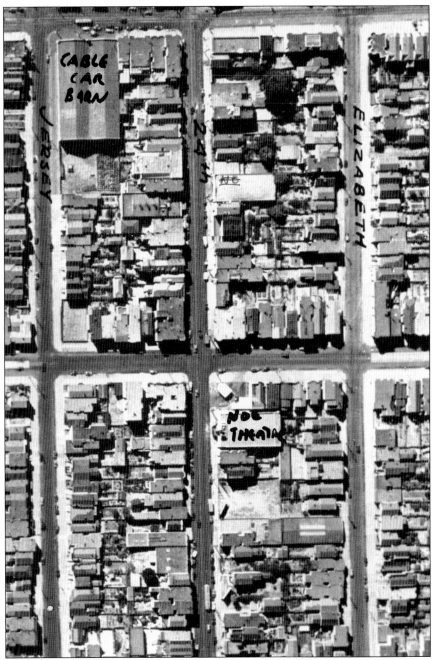

This photo centers on the corner of Twenty-fourth Street and Noe Street, showing Noe Valley as it appeared in 1937. For the most part, these buildings are still as they appear in this photograph. On the lower right corner of the intersection is what was then Charles Schroyer's gas station. A large vacant lot exists on the site where Bell Market would be built in 1968. In the interim, various businesses would occupy this site. At the bottom, we can see the Number 11 street car making its way west on Twenty-fourth Street, while at the top, the Castro Street Cable Car is just opposite the Cable Car Barn headed south to the turntable one block away. (U.S. Army photo, courtesy of the Noe Valley Archives.)

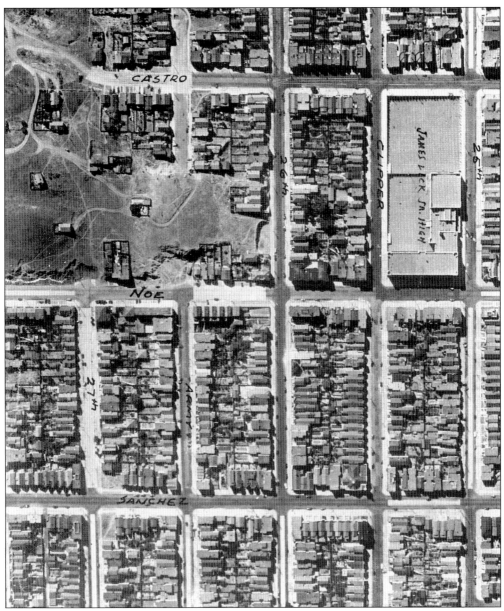

This 1937 aerial view by the U.S. Army Air Corps shows the point where Castro Street ended and became a dirt road, before the extension was paved and named Newburg Street. The cable car turntable at Twenty-sixth and Castro Streets is also visible. (U.S. Army photo, courtesy of the Noe Valley Archives.)

BELOW: Noe Valley's Alvarado Heights can be seen in the distance of this 1916 view looking northeast from the slopes of Twin Peaks. Crews are paving what was then Corbett Road, and now Corbett Avenue. Just below Corbett is Market Street, and just beyond that, the western edge of Noe Valley. (Courtesy author's collection.)

OPPOSITE, ABOVE: This view of Alvarado Heights was taken c. 1940 looking east from the same angle as the previous photograph. The tennis courts at the corner of Douglass and Elizabeth Streets can be seen at the bottom center. The paved trail on the north side of Alvarado Street above Diamond Street can be seen arcing across the hillside. This hillside would remain mostly vacant for another two decades. (Courtesy author's collection.)

OPPOSITE, BELOW: Alvarado Heights can be seen upper left in this recent photograph of western Noe Valley. The line of Queen Anne Victorian "high houses" along Twenty-third Street east of Diamond Street runs across the top center of this view. St. Philip's Church is on the right. (Photo by Bill Yenne.)

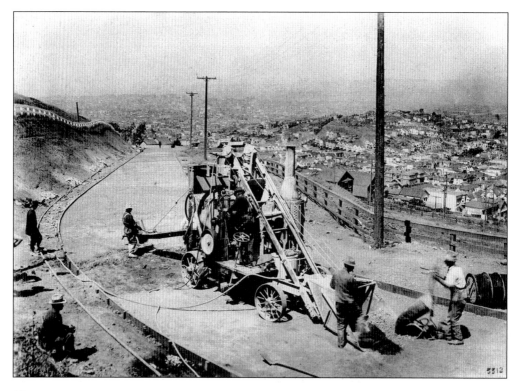

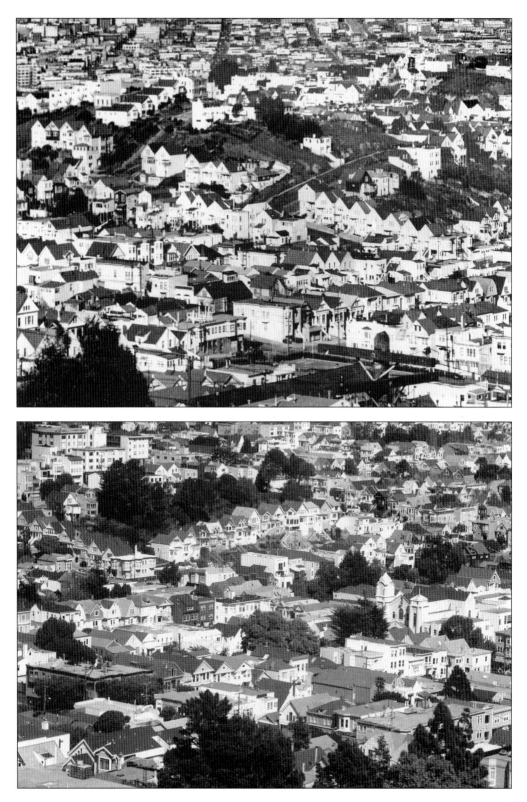

Corbett Avenue (top) intersects a serpentine Market Street in this 1937 U.S. Army Air Corps aerial view. Below are the western fringes of Noe Valley from Twenty-fifth Street on the left to Twenty-third Street on the right. Where Douglass Street crosses from left to right near the bottom, a large vacant lot is bounded by Twenty-fourth and Elizabeth Streets. The former site of the Noe Valley School, this became the Noe Playground, later Noe Courts. (U.S. Army photo, courtesy of the Noe Valley Archives.)

This photograph looks west toward Twin Peaks, with Alvarado Heights at the bottom center and Alvarado School in the center. This photograph was taken in 1957 by Al Woldow from his private plane. The street at the right is Twenty-second Street, while Twenty-third Street is on the left. Between these is Alvarado Street. The 600 block of the latter ends at Diamond Street, and the street resumes with its 800 block at Douglass Street. Countless people from outside Noe Valley seeking directions on Alvarado Street have expressed confusion and dismay over the "lost 700 block." (Courtesy of the Noe Valley Archives.)

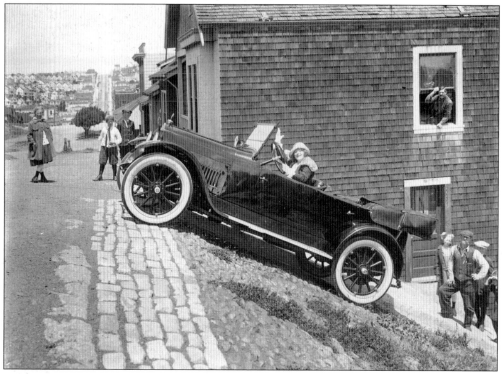

Finding her way across the hills of Noe Valley was no problem for this young lady in 1923. She has just climbed from Sanchez Street to Noe Street on Duncan Street. The trees in the background behind the boy in the white shirt are still there, near the corner of Twenty-seventh Street. At that time, Noe Street was still mostly gravel, and Duncan Street was paved in cobblestones. The house behind the car is still there, and although it was remodeled several times over the years, the side door on Duncan remains. (Courtesy of the Noe Valley Archives.)

Dolores Street, with its elegant line of Canary Island date palms is generally accepted as the eastern border of Noe Valley, although both adjacent main parallel streets have been suggested from time to time as alternate boundaries. (Photo by Bill Yenne.)

With Thirtieth Street the recognized southern perimeter of Noe Valley, the corner of Thirtieth and Church Streets, seen here, can be characterized as the southern "Gateway to Noe Valley." The maze of overhead cables reflects this corner's importance as a transit intersection. Both the J-Church street car and the Number 24 Divisadero electric bus pass this way. Until 1991, this was the terminus of the J-Church line. Since then, the line has been extended to south to the Balboa Park Bay Area Rapid Transit station. (Photo by Bill Yenne.)

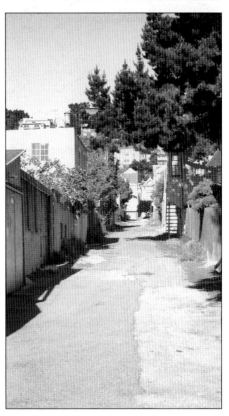

There are few places in Noe Valley where the notion of the valley as a "village within the city" is better illustrated than on quiet Comerford Street. Better known as Comerford Alley, this one block street is named for Joseph Comerford, one of the builders who constructed homes in the valley when it was still called Horner's Addition. (Photo by Bill Yenne.)

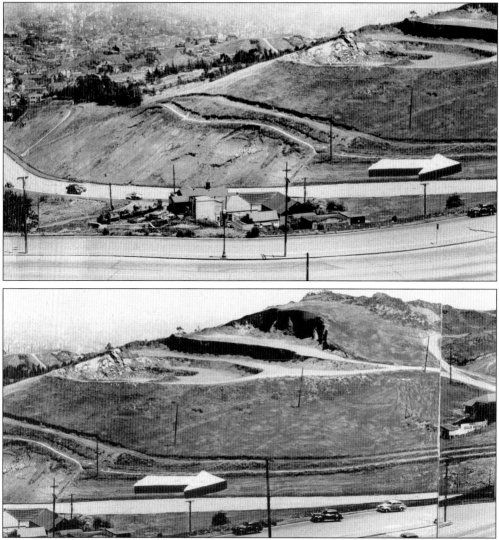

ABOVE AND OPPOSITE, ABOVE: The western "Gateway to Noe Valley" is Clipper Street, which intersects Market Street in the saddle between Diamond Heights and Twin Peaks. This series of photographs taken in June 1947 are looking southeast from Twin Peaks toward Red Rock Hill, the northern shoulder of Diamond Heights. The recently completed Clipper Street with the painted arrows pointing out of Noe Valley is visible. Clipper Street climbs out of the valley, intersecting Market Street, which runs in the foreground. Portola Drive extends west from this intersection. In the 19th century, the road that is now Portola was the beginning of the old San Miguel Toll Road. Jose Noe's Rancho de San Miguel extended west along the toll road to West Portal. (Courtesy author's collection.)

OPPOSITE, BELOW: Taken in March 1963, this photograph of the intersection of Clipper Street with Market Street shows the rapid pace of residential construction that had occurred on Diamond Heights during the 1950s. As can be seen, that construction work was still continuing in the 1960s. The bare hills that one sees in the backdrop of early pictures of Noe Valley were inexorably changed by the burst of activity in both Diamond Heights and Twin Peaks during this era. The Texaco station survived until the 1980s. (Courtesy author's collection.)

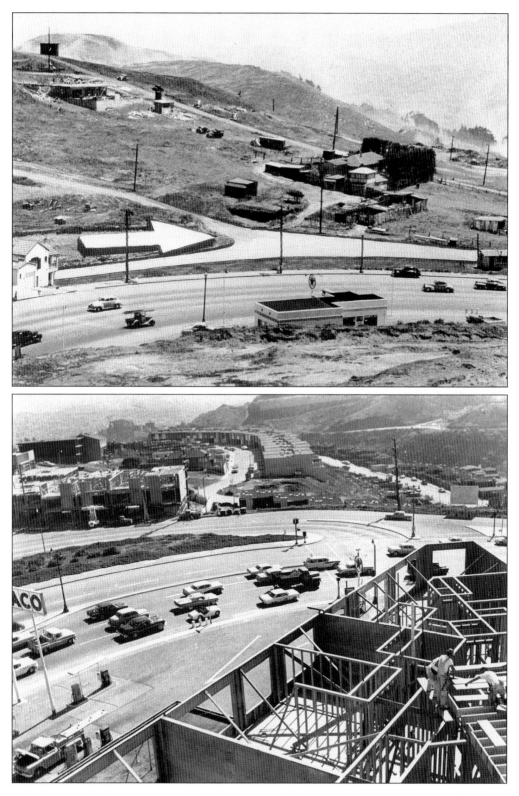

This Italianate-style Victorian on Castro Street is typical of those constructed across Noe Valley in the 1880s and 1890s by builders such as Jonathan Anderson and Fernando Nelson. (Photo by Bill Yenne.)

The Queen Anne Victorians, such as these on Alvarado Street, were distinct from the Italianate and "San Francisco Stick" style homes in that they featured peaked roofs. Queen Annes constructed on corners also often featured turrets. (Photo by Bill Yenne.)

As can be seen in this photograph taken on Sanchez Street at Twenty-eighth Street, early 20th century Spanish-style architecture fits comfortably with 19th-century Victorians in Noe Valley. (Photo by Bill Yenne.)

Featured in this morning street scene in Noe Valley, the benches that many Twenty-fourth Street merchants installed in the 1990s have added considerably to the valley's cherished small-town atmosphere. (Photo by Bill Yenne.)

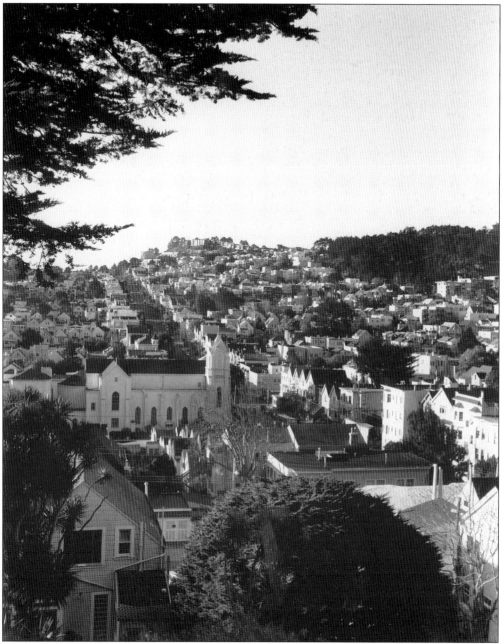

Cypress trees frame an early morning view of Noe Valley looking south toward Diamond Heights. St. Philip's Church is visible in the center. (Photo by Bill Yenne.)

Who's buried in Noe's tomb? The family crypt is located beneath the floor of Mission Dolores. Noe's wife, Guadalupe, and their children Maria Concepcion and Esperidion were buried here between 1848 and 1861, but Jose is not listed. There is room on the family's marble slab for his name, but it is conspicuously absent. He is known to have died in 1862 and is reported to have been buried at the mission, but where remains a mystery. (Photo by Bill Yenne.)

One

THE HISTORY OF NOE VALLEY

NOE VALLEY BEFORE NOE

In the years before the arrival of Europeans, the encampments of the indigenous peoples of the area were concentrated near the bay, on the eastern side of what is now San Francisco. People may well have lived in what is now Noe Valley—and they almost certainly hunted deer here—but there is no evidence of a major settlement having existed prior to the arrival of the Spanish.

As he was coasting north in 1579, Sir Francis Drake may have seen the western side of Twin Peaks that were opposite Noe Valley. However, he missed the entrance to San Francisco Bay in the fog and made landfall in Marin County at what is now known as Drake's Bay, so he never set foot in Noe Valley.

Nearly two centuries later, the Spanish were establishing their string of missions and other settlements along the California coast. In March 1776, a party led by Lt. Col. Juan Bautista de Anza and Lt. Jose Joaquin Moraga arrived in what is now San Francisco. They were scouting north from the Presidio of Monterey, tasked with locating sites near the mouth of San Francisco Bay for both a presidio—or military post—and a mission. They camped by a small lake near what is now the corner of Dolores Street and Eighteenth Street, about a quarter of a mile northeast of Noe Valley. They named the area in which they camped Arroyo de Nuestra Senora de los Dolores (Valley of Our Lady of Sorrows). When de Anza reported back to Monterey, it was decided that the spot would be a good place for the sixth in the chain of missions that were being established by the Franciscan friars under Fr. Junipero Serra.

In June 1776, a group of colonists and two Franciscans, Fr. Francisco Palou and Fr. Benito Cambon, returned to the lake to celebrate mass and begin work toward establishing the mission. Founded on June 29, 1776, and formally dedicated on October 9, 1776, the mission was originally named for San Francisco de Asis (Saint Francis of Assisi), the founder of the Franciscan order. Though the little mission became the namesake for the city of San Francisco, it would, itself, be known popularly as "Mission Dolores" for the Arroyo de Nuestra Senora de los Dolores.

The actual mission church was a small tule arbor structure located at what is now the corner of Camp and Albion Streets, which are short streets located near the corner of Guerrero and Sixteenth Streets. In 1782, the cornerstone for the permanent—and present—mission church was laid less that two blocks west on what is now Dolores Street near Sixteenth Street.

During the mission period, which lasted until 1833, when the Mexican government secularized the missions and began selling off their land, it is probable that livestock belonging to the mission were grazed on the hillsides of what is now Noe Valley. Certainly the streams that ran through the valley would have been a good source of water for the animals.

As present-day Noe Valley residents know all too well, there are numerous springs throughout the valley and the surrounding hills. In the winter, these springs form small streams that are visible running down the streets and through backyards. In the years before Noe Valley was developed, there was a semi-permanent stream that originated in the vicinity of what is now Jersey and Diamond Streets. It ran in a southeasterly direction, passing Noe Street at Twenty-sixth Street. It reached Church Street between Twenty-seventh and Duncan Streets and flowed generally east across the northern base of Bernal Heights and emptied into Islais Creek on the eastern side of Bernal Heights.

During the early 19th century, settlements had grown up around many of the missions, and the one at San Francisco was certainly no exception. Actually, there were three principal settlements within the 49 square miles that comprise present San Francisco. There was one near the mission, and one near the Presidio. The most commercially active was the small port village of Yerba Buena, which was located on the shore of the bay in the area around what is now the foot of Market Street. Though the mission would ultimately lend its name to the city, it was originally just an outpost several miles inland from the real action.

The rest of the 49 square miles was essentially open land. As with much of the rest of the Bay Area, this land was granted by the government to wealthy ranchers and prominent families who had been living in California since before Mexico had declared its independence from Spain in 1821. Among the land grants within present San Francisco were those issued to families such as De Haro, Leese, Bernal, Galindo, and Noe.

Don Jose de Jesus Noe served two terms, separated by four years, as alcalde of Yerba Buena. When he left office in 1846 as the city's last Mexican alcalde, he retired to his Rancho de San Miguel. Part of the ranch is now Noe Valley. (Illustration by the author.)

This map dating from the late 1840s identifies the city as "Yerba Buena, or San Francisco." It also refers to Noe's Rancho de San Miguel land grant simply as the "Noe Rancho." As can be seen in this map, the rancho occupied a sizable section of San Francisco. (Courtesy of author's collection.)

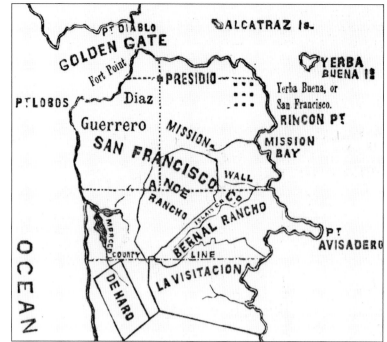

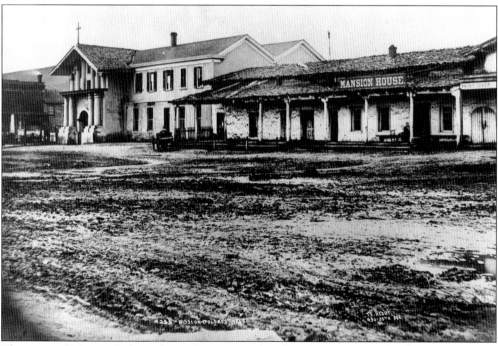

This view of Mission Dolores shows the mission church and the surrounding area as it appeared in 1865. Rancho de San Miguel lies beyond the hills that are barely visible in the distance. Before his death in 1862, Don Jose de Jesus Noe and his family attended mass here. (Courtesy of author's collection.)

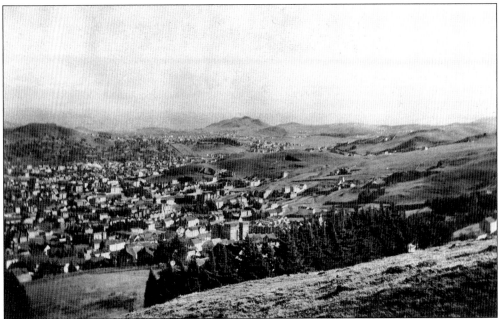

This view looking southwest from Twin Peaks includes Horner's Addition off to the left and Red Rock Hill in the center. Bernal Heights is visible in the distance on the left. (Courtesy of the Noe Valley Archives.)

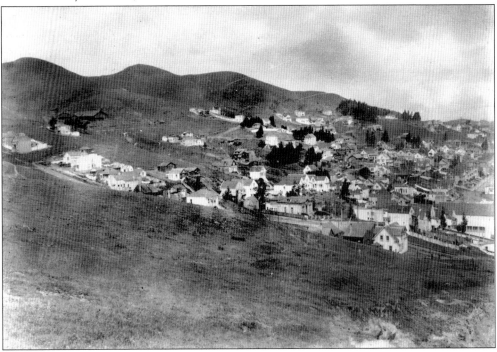

The western edges of Horner's Addition appear in this view looking northwest from Red Rock Hill toward Twin Peaks, possibly as early as the 1880s. Running up the hill is Twenty-fifth Street. Clipper Street did not yet extend uphill from Douglass Street. (Courtesy of the Noe Valley Archives.)

26

HORNER'S ADDITION

Before Noe Valley was known as Noe Valley, it was known as "Horner's Addition," after the man who turned the rolling pastures of Rancho de San Miguel into some semblance of an urban neighborhood.

If Jose de Jesus Noe can be considered the namesake of Noe Valley, it can be argued that John Meirs Horner was the father of Noe Valley. Born in June 1821 on a farm in Monmouth County, New Jersey, Horner became a baptized member of the Church of Jesus Christ of Latter-day Saints (the Mormons) in 1840. After several years at the major Mormon settlement in Nauvoo, Illinois, he joined a group of Mormons who were bound for California. In 1846, the year of the Bear Flag Revolt, Horner arrived in Yerba Buena with his young wife, the former Elizabeth Imlay.

The Mormon settlers came, not for the city life of the village by the bay, but as farmers, so they set out for the lower San Joaquin Valley. Horner planted a farm on 40 acres that he had leased from a fellow Mormon, Dr. John Marsh. In 1847, however, Horner relocated back to the Bay Area, settling near Mission San Jose, which is in the present city of Fremont. His hopes for a better harvest were dashed by drought, but in early 1848, Horner decided on a new venture in his elusive search for prosperity in California. The news of James Marshall's gold discovery at Sutter's Mill had leaked out. The trickle of prospectors that began in 1848 would become a tidal wave in 1849. Horner was among the first, but once again, riches eluded him.

In 1848, Horner bought another farm near what is now the city of Vallejo and tried again. Though Horner discovered that farming was not his cup of tea, he found that buying and leasing farm land and brokering produce were his keys to success. By 1850, J.M. Horner & Company had incorporated in San Francisco, and Horner was the largest contributor to the first agricultural fair held in California.

Horner bought a substantial amount of land in Alameda and Santa Clara Counties. He also purchased 5,250 acres in what is now San Francisco, but which, in 1852, was outside of city limits. This included a sizable slice of the old Rancho de San Miguel that had been owned by Jose de Jesus Noe. Horner's land holdings closely conformed to what is now Noe Valley. In 1850, at the time of California statehood, the southwestern corner of San Francisco was located at 17th and Webster Streets. A year later, this corner of the city limits was pushed out to Twenty-second and Divisadero Streets. In 1856, through the Consolidation Act, the City and County of San Francisco became contiguous within their present borders.

John Horner correctly predicted that his portion of Rancho de San Miguel, which came to be known as "Horner's Addition," would eventually be incorporated into the city limits of San Francisco. Planning to sell lots for homes, Horner laid out the present street grid and named the streets. He named one of his new thoroughfares Horner Street, and a block south, Elizabeth Street was named for Mrs. Horner.

Horner's fortunes declined during the national economic downturn of 1857–1859, and he was forced to sell much of his California property at a loss. In 1879, he relocated to Hawaii, where he died in 1907 at the age of 86.

In the meantime, many of the names that Horner had assigned to his grid of streets were changed. In 1861, every other street was numbered. Elizabeth Street would remain, but nearby John Street became Twenty-second Street and in between, the founder's own Horner Street became Twenty-third Street. At the foot of Horner's Addition, his Grove Street became Thirtieth Street, while Park Street, the growing economic hub of the area to the west of Dolores Street, became Twenty-fourth Street.

By the 1880s, another robust commercial district had developed on Church Street in the blocks north and south of Twenty-ninth Street, which Horner had originally designated as Dale Street. The important businesses in the area included Sam Brown's barber shop, Stelling's Grocery, and the Fairmount Market. The latter occupied the site that later became Drewes Meat Market.

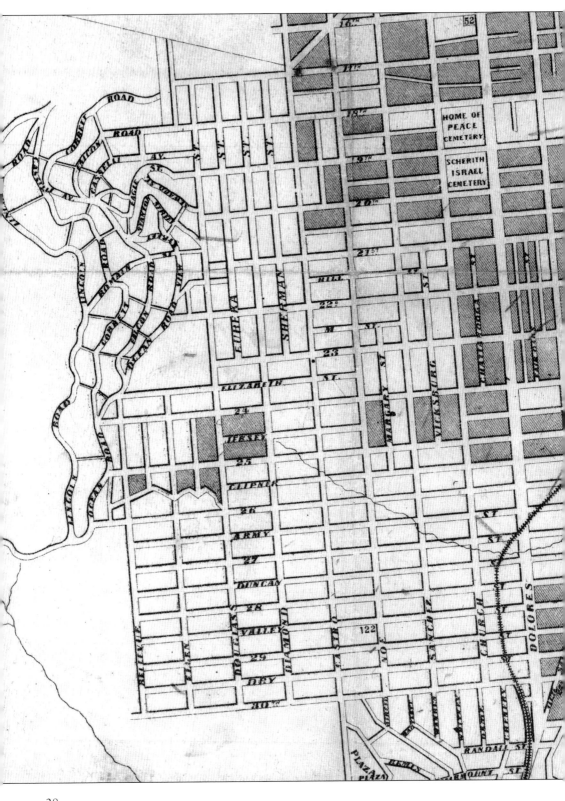

Dating back to 1877, Axford House is typical of the homes that existed in Horner's Addition in the 19th century. Located at the corner of Noe Street and Twenty-fifth Street (originally Navy Street), the house is constructed in the Italianate style characteristic of the period. (Photo by Bill Yenne.)

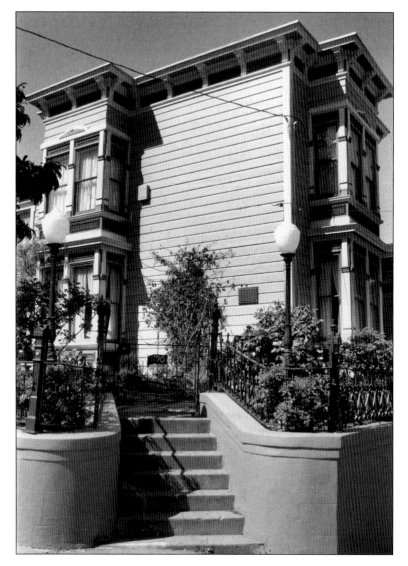

OPPOSITE: In this 1873 map of Horner's Addition, we can see the neat and precise grid of streets that Horner laid out across this section of Rancho de San Miguel. For the most part, his grid ignored topographical features, but some places were just too steep for roads. Clipper Street (here called "Clipner") stopped at Douglass and did not attempt to climb Red Rock Hill. An unnamed alley winds west across the hill from the intersection of Douglass Street and Twenty-sixth Street (formerly Navy Street). Both Thirtieth and Dolores Streets are clearly defined perimeters of the addition, and the center of development was between Dolores and Church Streets and west along Twenty-fourth Street as far as Noe Street. In this area was Margery Street, which has since vanished. There was another concentration of structures around Jersey and Douglass Streets. Sherman Street became Collingwood Street and it was shortened north of Twenty-second Street, while M Street became Alvarado Street and was extended west. Noe Valley's first railway line, the San Francisco & San Mateo Electric Railway can be seen snaking through the lower right hand corner. The old San Miguel Toll Road extends west from the lower left corner. (Courtesy of author's collection.)

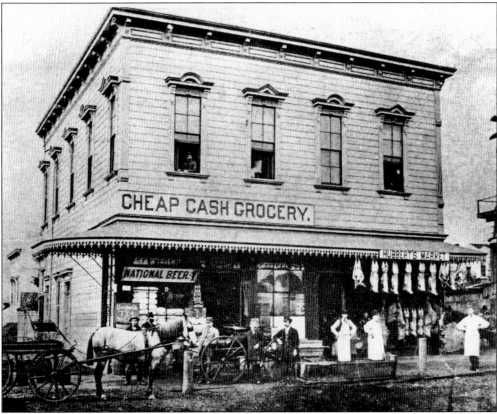

The corner of Twenty-fourth and Church Streets was the center of the business district in Horner's Addition when this picture was taken in 1878. On the corner is the Hoffmann family's "Cheap Cash Grocery" store, while facing the Twenty-fourth Street side is Hubbert's meat market. (Courtesy of the Noe Valley Archives.)

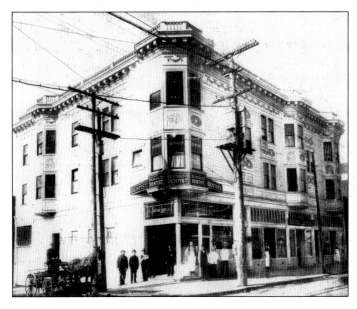

In 1907, Horner's Addition had become known as Noe Valley and the small building that housed Hoffmann's grocery was replaced by this imposing Victorian structure. Hubbert's meat market had been superseded by the Oakwood Market. Many of the commercial buildings had dentists operating from second-floor offices. As seen opposite, this building remains relatively unchanged today. (Courtesy of the Noe Valley Archives.)

NOE VALLEY AFTER NOE AND HORNER

After John Horner left the scene in 1857 and Jose Noe died in 1862, a number of other individuals had a role in what would continue to be known for many years as Horner's Addition. Among them would be Jose de Jesus Noe Jr., who, along with other Noe family members, spent many years in court trying to reclaim Rancho de San Miguel. The younger Noe died in 1872 at the age of 29 without having accomplished this objective.

Meanwhile, Horner's Addition would start to evolve as the "village within the city" that Noe Valley is today. Whereas Jose Noe had once grazed cattle on the hills and dales of what is now Noe Valley, Horner had opened the door to smaller-scale activities, including small garden plots and individual homes.

Horner's Addition became the destination of the late 19th century wave of immigrants, including people from Ireland, Italy, Russia, Scandinavia, and the various states of the German Empire. As ranchers had been replaced by farmers, the latter were replaced by butchers, bakers, and other tradesmen, as well as firemen, policemen, and other civil servants.

During the late 19th century, Noe Valley was gradually making the transition from ranch to farm to working-class suburb filled with homes and businesses constructed in the picturesque Victorian architectural style that is still part of the character of Noe Valley. It was during the 1880s and 1890s that Noe Valley experienced the building boom giving the neighborhood its architectural character. Three of the most important builders during this era were Jonathan Anderson, Joseph Comerford, and Fernando Nelson—who is said to have constructed more than 4,000 Victorians across San Francisco.

The prices for these homes ranged from as little as $20 per room for a cottage to upwards of $420 per room for a large, ornate Victorian. Carpenters and electricians were paid 50¢ an hour, but bricklayers were paid 75¢. Unfortunately, many homes wound up with brick foundations, which are potentially unstable during an earthquake. Nevertheless, many Noe Valley buildings with brick foundations survived all three of the major San Francisco quakes of the 20th century in 1906, 1957, and 1989. Current code requires upgrading to concrete with the wood frames bolted to the concrete.

The well-used Victorian building at Twenty-fourth and Church Streets seen opposite is still there in the 21st century and looking good in a multi-tone modern paint job. (Photo by Bill Yenne.)

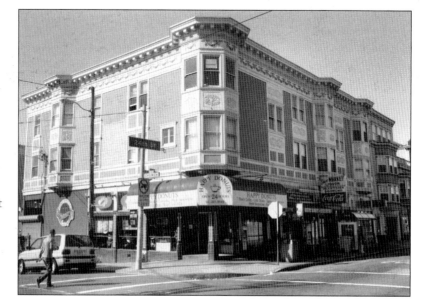

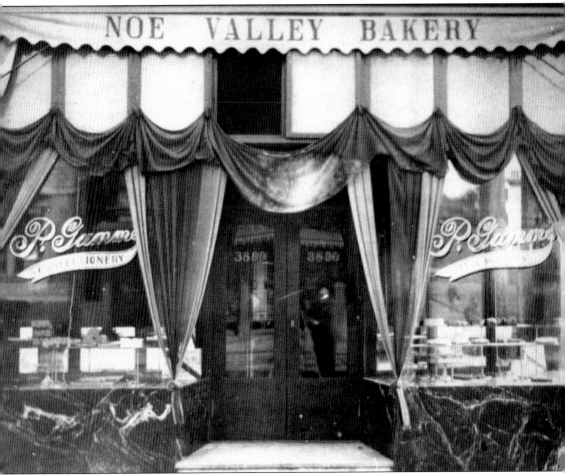

At the end of the 19th century, Gumm's Confectionery and Noe Valley Bakery occupied the building facing Twenty-fourth Street at Sanchez Street. At the turn of the 21st century, the Designer's Club occupied this site, and an unrelated Noe Valley Bakery was located a block and a half west on Twenty-fourth Street. The distinctive pattern in the marble beneath the windows is still visible. (Courtesy of the Noe Valley Archives.)

OPPOSITE, ABOVE: Dan Maloney, a pioneer "aeronaut" and glider pilot, is seen here with one of his machines atop Red Rock Hill sometime around the turn of the 20th century. A former circus performer, he became a glider pilot and performed often at Glen Park. He is recalled as having been a great success until he crashed in Santa Clara on July 18, 1905. (Courtesy of Mitchell Family Archives, via Karen Hanning.)

OPPOSITE, BELOW: Around the turn of the century, Antonio Mazzeta's New Twin Peaks Fruit Market was located in this Italianate mixed-use building at the corner of Twenty-third and Douglass Streets. (Courtesy of the Noe Valley Archives.)

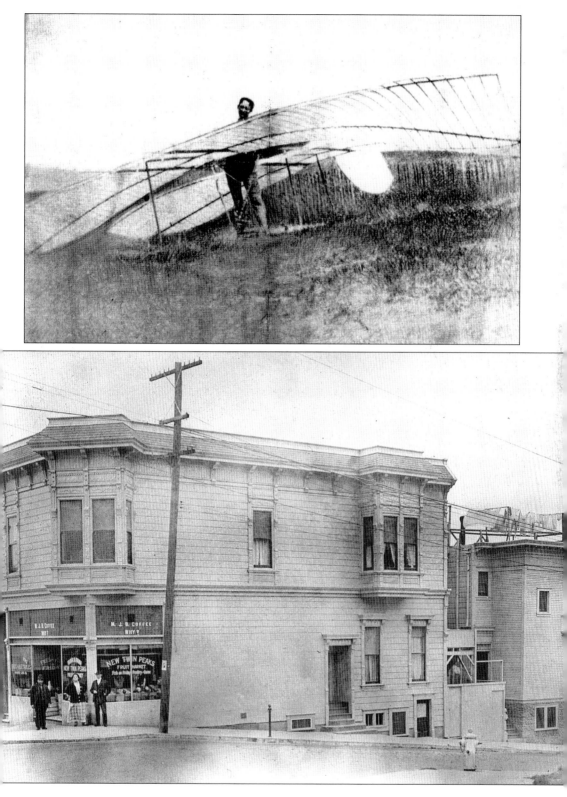

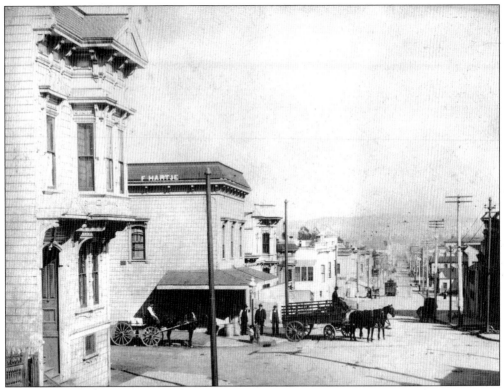

In this view looking east along Twenty-second Street toward the Mission District from Chattanooga Street, the little Number 11 streetcar makes its way toward Noe Valley. Hartje's grocery store is on the left of this 1903 photo. (Courtesy of the Noe Valley Archives.)

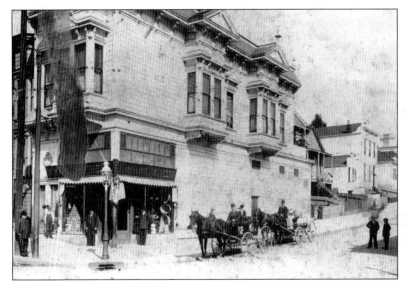

Long a fixture on Twenty-second Street in the late 19th century and early 20th century was F. Hartje's grocery store. These may be members of the Hartje family decked out in their Sunday finery to pose for this photograph. (Courtesy of the Noe Valley Archives.)

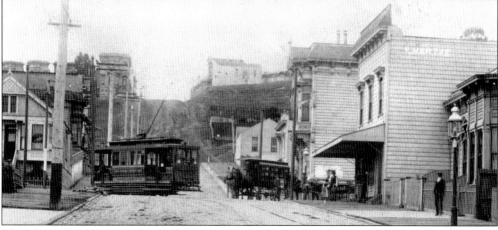

The Mission and Twenty-fourth Street electric trolley makes the turn at the corner of Twenty-second and Chattanooga Streets. In the background is the notorious Twenty-second Street Hill. With a 31.5 percent grade, it is tied with Filbert Street between Hyde and Leavenworth Streets as the steepest block in San Francisco. (Courtesy of the Noe Valley Archives.)

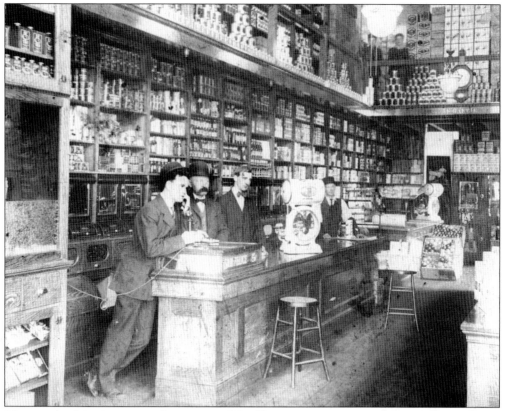

It's a step back in time to see the interior of the Hartje grocery store as it appeared more than a century ago. Canned goods line the shelves and produce is displayed in open wooden crates. Most of the staff stands at the ready as one young man takes a telephone order. Modern communication was in the process of revolutionizing the grocery business. (Courtesy of the Noe Valley Archives.)

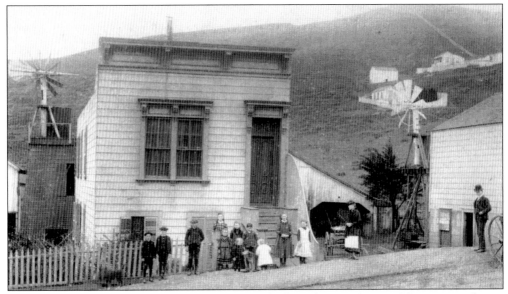

The Mitchell Dairy was founded by Edward Mitchell in about 1860 on 16 lots centered near what is now the corner of Twenty-ninth Street (originally Dale Street) and Noe Streets. The cows would graze on the slopes of Red Rock Hill. When Edward died, the business was taken over by his widow, Margaret O'Conner Mitchell, who is seen toward the right in this 1890 photograph wearing a white apron, which was, according to family folklore, "embroidered by the nuns." Mitchell's survived longer in one place than any other dairy in Noe Valley. Grandsons Jack and Lawrence Mitchell would later start the legendary Mitchell's Ice Cream on San Jose Avenue. Note the flue for the Crystal Springs Water Company coming downhill on the right. (Courtesy of Mitchell Family Archives, via Karen Hanning.)

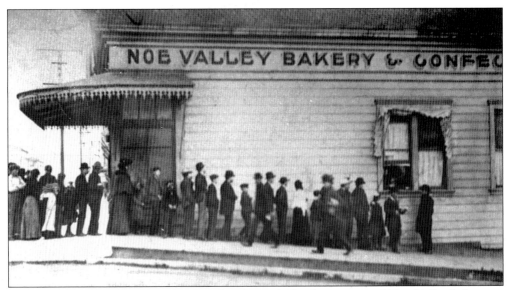

Noe Valley residents line up to buy bread at Gumm's Confectionery and Noe Valley bakery on Twenty-fourth Street shortly after the April 18 earthquake. The source of the post-quake firestorm had been cooking fires in houses with damaged flues and chimneys, so cooking at home was banned, and people had to go out for bread. (Courtesy of the Noe Valley Archives.)

THE GREAT EARTHQUAKE

San Francisco's signature event was the Great Earthquake of April 18, 1906. Historically, events from the history of San Francisco are still identified as "pre-Earthquake" or "post-Earthquake." Owners of classic Victorian properties also use this demarcation system, proudly identifying "pre-Earthquake" homes as being robust and sturdy.

The Great Earthquake did considerable damage, especially in the areas of downtown San Francisco east of Montgomery Street that had been constructed on landfill. There was also major damage in low-lying sections, especially in the Mission District, where buildings had been constructed along or atop streams. However, most of the major devastation that is often attributed to the Great Earthquake was actually caused by a series of fires that started in the hours following the temblor itself. As the fires merged into one massive conflagration, virtually every wooden structure in all of the northeast quadrant of what is now the City and County of San Francisco—nearly 500 square blocks—was leveled.

In Noe Valley people felt the 8.3-magnitude earthquake, but, because the neighborhood is mostly constructed on bedrock, damage was minimal compared to much of the rest of the city. Water lines broke and brick chimneys toppled, but the wooden structures flexed and survived. More important, the fire never reached Noe Valley. For this reason, a sizable proportion of the housing stock in Noe Valley can still be identified as "pre-Earthquake."

In the 7.1-magnitude Loma Prieta Earthquake of 1989, most of Noe Valley survived unscathed, although there were isolated pockets of damage in areas where buildings were situated atop former stream beds. The Church Street corridor, especially in the area around the church and schools of St. Paul's Parish, suffered more than most areas of Noe Valley

In the days and weeks following the 1906 earthquake, people were forbidden to cook in their houses because of the fire danger—so they took to the streets. Kitchens in the streets were a common sight in Noe Valley and throughout the city until chimneys were repaired and the ban was lifted. (Courtesy of the Noe Valley Archives.)

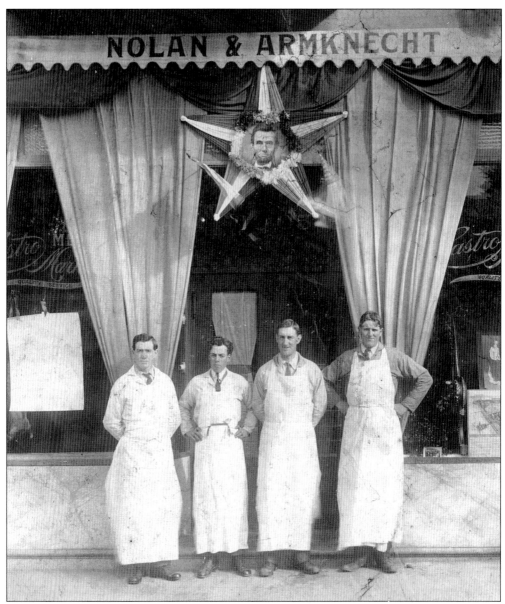

Abraham Lincoln was the theme at the Nolan & Armknecht Castro Meat Market, c. 1915. An Irish and German partnership on the site on Castro Street between Twenty-fourth and Jersey Streets, it was a meat market for much of the 20th century. The poster in the window at the right features a map of the Panama-Pacific International Exposition that celebrated San Francisco's recovery from the Great Earthquake. At the turn of the century, a restaurant at this location called Hahn's Hibachi featured Korean cuisine. (Courtesy of the Noe Valley Archives.)

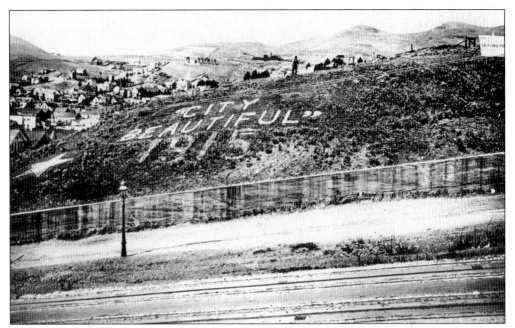

"City Beautiful" was the theme of this civic-minded signage that appeared at a commercial poppy field in 1915 at the time of the Panama-Pacific International Exposition. This view was taken looking west from the 1000 block of Castro Street, bounded by Alvarado Street on the right and Twenty-third Street on the left. In the distance are the houses of upper Noe Valley with Red Rock Hill and Twin Peaks on the horizon. (Courtesy of the Noe Valley Archives.)

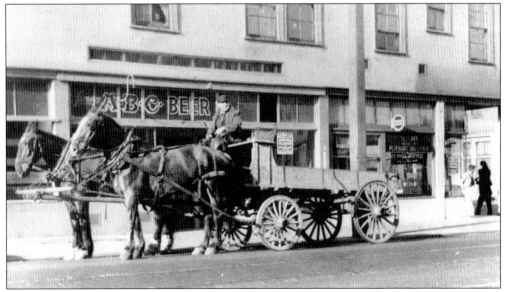

A draft-horse team and heavy delivery wagon are pictured on Twenty-fourth Street in Noe Valley early in the 20th century. Possibly this was a beer shipment arriving in the valley. ABC Beer was a product of the Maier Brewing Company of Los Angeles, a company that dated back to 1874, but did not begin "exporting" its product to San Francisco until the turn of the 20th century. (Courtesy of the Noe Valley Archives.)

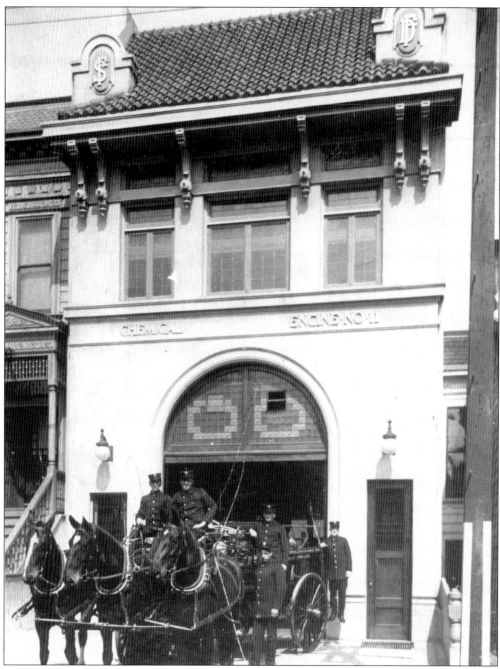

It was in July 1907 that San Francisco Fire Department chief engineer P.H. Shaughnessy recommended the creation of a new chemical company on Twenty-second Street, near Noe Street. Opened in 1910 as Chemical Company 11, it became Engine 44 in 1916. (Courtesy of the Noe Valley Archives.)

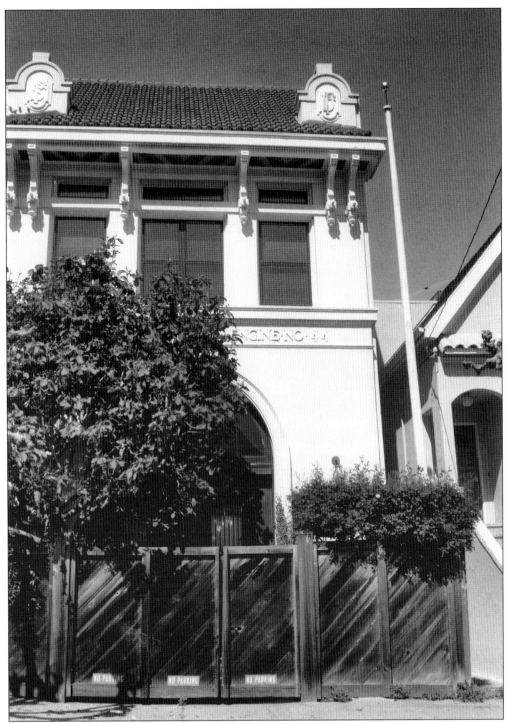

The firehouse on Twenty-second Street became Engine Company 44 in 1918 and a hose company in 1922. Engine 44 returned in 1928 and remained for three decades, when this firehouse joined the list of many across San Francisco that were taken out of service and became a private home. (Photo by Bill Yenne.)

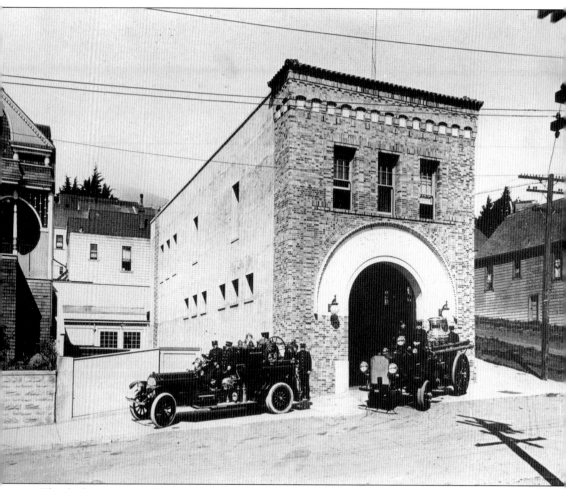

The firehouse on Hoffman Avenue at the corner of Alvarado Street was constructed in 1914. The original firemen were Captain Gillick (seen here at the wheel), Ed O'Neill, Bill Johnson, George Droulett, Dan Vocke, Charles Vocke, Fred Pope, Engineer Jack Brady, and Lieutenant Bean. Their mascot was a setter named "Pope." (Courtesy of the Noe Valley Archives.)

OPPOSITE: Still home to San Francisco Fire Department Engine Number 24, the firehouse on Hoffman Avenue at Alvarado Street is the oldest station in the city. (Photo by Bill Yenne.)

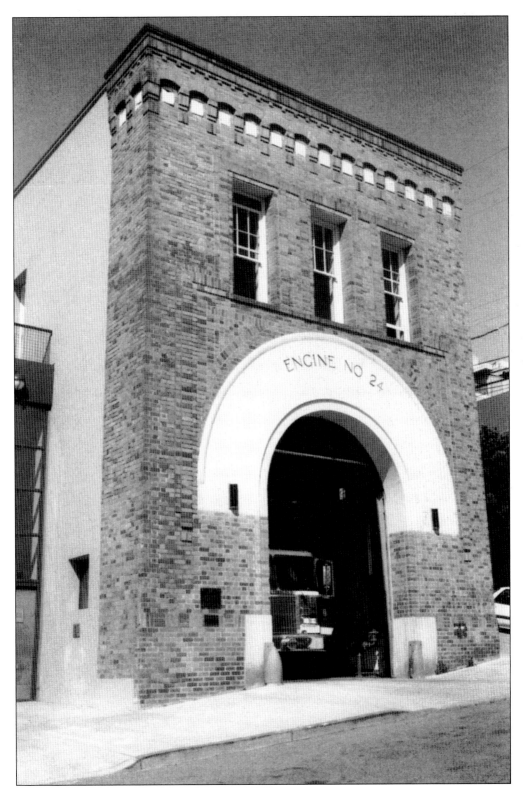

BELOW AND OPPOSITE, ABOVE: The west side of the 400 block of Douglass Street north of Twenty-first Street climbs to about ten feet higher than the east side. These three photographs, taken between September 1918 and August 1927, show the steps taken to split the street into two level lanes. (Courtesy of the Noe Valley Archives.)

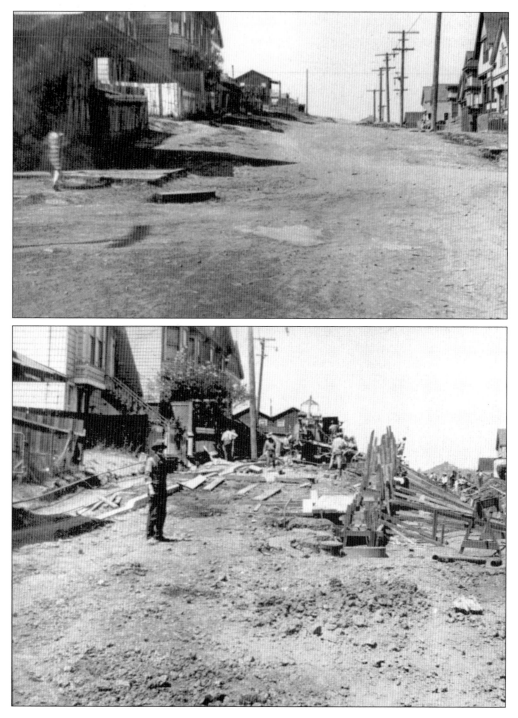

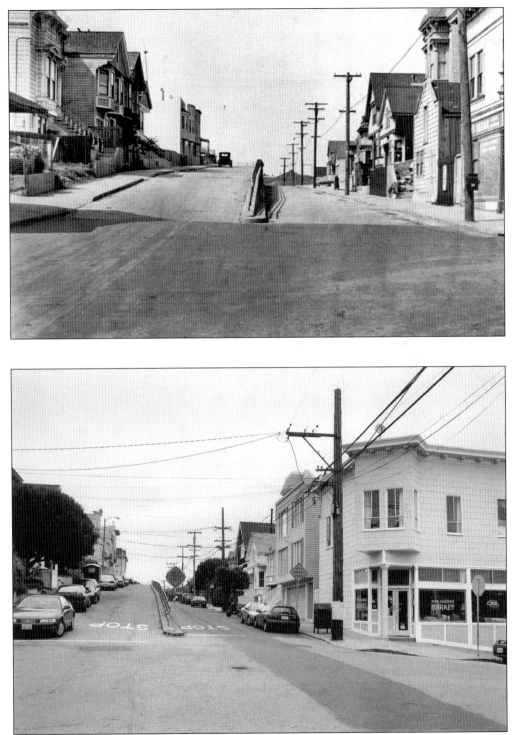

Today, both halves of Douglass Street north of Twenty-first Street are open to two-way traffic, although only the upper portion is a through street. On the corner, Riley's Bazaar (later Nader's Grocery) became the Noe Corner Market. (Photo by Bill Yenne.)

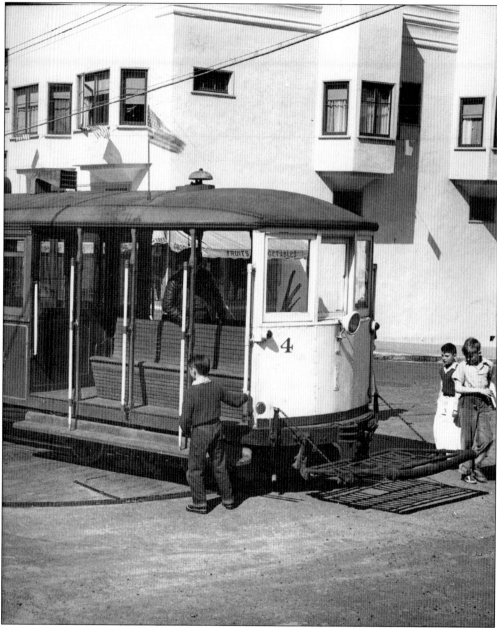

There is something about boys and big machines, especially trains. These three Noe Valley kids are taking an interest in the cable car, and one is even attempting to lend a hand to turn the car on the turntable at Twenty-sixth and Castro Streets. (Courtesy of the Noe Valley Archives.)

Two

RAILS COME TO THE VALLEY

A necessary step in the integration of any district into the fabric of the civic life of the city at large is transportation. In the early days, Noe Valley was a rural community that was roughly an hour's ride from the heart of San Francisco. When John Horner laid out his street grid, people moved in, bought lots and his "Addition" soon evolved from a separate village into a San Francisco neighborhood. A growing number of people in Noe Valley were working or shopping in downtown San Francisco. There was now a demand for mass transit.

The first man to bring a railway line to Noe Valley was Behrend Joost. Born near Hannover, Germany, Joost arrived in San Francisco 1857, having been lured to the city by his brother, already a prosperous businessman here. After working for his bother as a salesman for a couple of years, Behrend opened a grocery store on the old Mission toll road—now Mission Street—in 1859. This location, at Eleventh Street, would later be the site of the Joost Brothers Hardware Store. Among Behrend Joost's other ventures were the Clarendon Heights Land Company and the Sunnyside Land Company; however, he is best known for the San Francisco & San Mateo Electric Railway.

Work on the San Francisco & San Mateo Electric Railway began in 1889, though it was not officially sanctioned by the San Francisco Board of Supervisors until 1890. In any case, the cable cars were running from the foot of Market Street in San Francisco to the San Mateo County line by July 1891. Naturally, the Clarendon Heights and Sunnyside neighborhoods were linked by the route to downtown San Francisco. The line also passed through Horner's Addition and into Glen Park by way of Chenery Street. Joost is memorialized by Joost Avenue, which runs through Sunnyside and Glen Park, and his home still stands at 3224 Market near Nineteenth Street. The railway became part of the United Railroads of San Francisco (URR) in 1902, which, in turn, became part of the City-owned San Francisco Municipal Railway (Muni).

Across the hills in downtown San Francisco, several other pioneer urban railway companies were forming. Notable among these was the Market Street Railroad Company, founded in 1857 by Thomas Hayes, the namesake of Hayes Street in the Western Addition. By 1860, he was operating several lines, including a steam train on Market Street. In 1873, cable cars began running across town on Nob Hill. Invented in San Francisco by Andrew Hallidie, cable cars revolutionized urban rail travel, especially in cities such as San Francisco, with its steep hills. The Market Street Railroad replaced steam and horse-drawn cars with cable cars and evolved into the Market Street Cable Railway Company.

By 1887, as Behrend Joost was planning his line across Noe Valley's southern edge, the Market Street Cable Railway Company had brought rails to the northern part of what is now Noe Valley. The route across the steep, 20-percent grade of the Castro Street Hill was initially a cable line from the Ferry Building via Market and Castro to Twenty-sixth Street. In 1907, the cable line was shortened to run only between Eighteenth and Twenty-sixth Streets. Streetcars ran from Eighteenth Street to the Ferry. Known as the White Front cars, these cable cars ran between Twenty-sixth Street in Noe Valley and Eighteenth Street in Eureka Valley,

one block south of the transit corridor on Market Street. A car barn was constructed in Noe Valley, one block north of the Twenty-sixth Street turntable at Jersey and Castro.

Meanwhile, in 1902, the Market Street Cable Railway Company was merged into the URR. In 1921, the URR was reorganized, ironically, as the Market Street Railway.

Today, against the backdrop of a nostalgia for the glory days of cable cars, it seems that the Castro Hill cars would have been desirable, but in the late 1930s cable cars were viewed as archaic. The people of Eureka Valley actually lobbied San Francisco Public Utilities Commission manager E.G. Cahill for the abandonment of cable service in favor of a Muni bus line. In 1939 Cahill argued against this, telling Mayor Angelo Rossi that $80,000 would be necessary to replace the cable cars with electric buses, and that the cable line's monthly income was less than $1,000. Cahill also complained that the hill was too steep for buses, but the handwriting was on the wall.

April 5, 1941, marked the end of the line for the cable cars, as White Front cable service to Noe Valley was officially terminated. Three years before, the Market Street Railway was taken over by the San Francisco Municipal Railway. The cable and rails were ripped out, and the route was serviced by a succession of diesel and electric buses operating as Muni's Number 24 Divisadero line.

Meanwhile, the Market Street Railway operated two electric street car lines in Noe Valley. Most prominent of these was the Number 11 Mission and Twenty-fourth Street electric car that ran along Noe Valley's main thoroughfare, Twenty-fourth Street. It ran on Twenty-fourth Street from Hoffman Avenue to Dolores Street, from which it jogged north to Twenty-second Street, where it turned east to Mission Street. On its return run to Noe Valley, the car travelled between Twenty-second and Twenty-fourth Streets on Chattanooga Street. The Number 11 street car was later superseded by the Number 11 Mission and Twenty-fourth Street electric car and Number 48 Quintara bus lines. The lesser known Market Street Railway line in Noe Valley was the Number 9 trolley. It had its terminus at Noe Street, crossed the Valley on Twenty-ninth Street, and traveled all the way downtown by way of Valencia and Market Streets.

The City-owned San Francisco Municipal Railway opened its first two electric trolley lines in 1912, and reached Noe Valley with its J-Church line in 1917. It traveled on Market Street from the Ferry Building to Church Street, then turned south. Bypassing the steepest part of Dolores Heights, it departed from the Church Street corridor at Twentieth Street to run through the backyards of several blocks. It rejoined Church Street at Twenty-second Street and ran due south to Thirtieth Street. After more than eight decades of ending at Thirtieth Street, the J-Church line was extended south to the Balboa Park Bay Area Rapid Transit station in 1994.

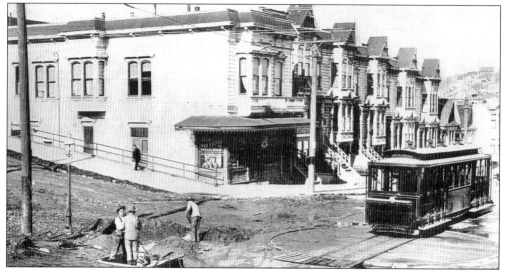

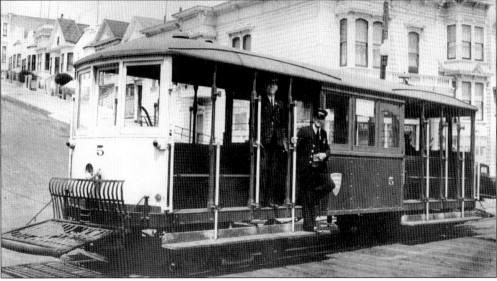

Uniformed gripmen pose aboard a white-fronted Castro Street cable car at the completed turntable at Twenty-sixth and Castro Streets in 1938. Note the Market Street Railway Company logo on the car. (Courtesy of the Noe Valley Archives.)

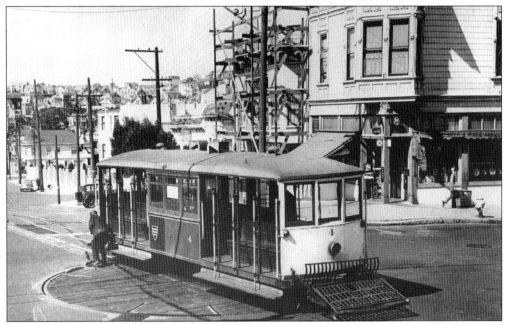

A gripman turns his car on the turntable at Twenty-sixth and Castro Streets in 1940. The building under construction in the background is still standing. (Courtesy of the Noe Valley Archives.)

Opposite: The Noe Valley turntable for the Castro Street Cable Car was located at Twenty-sixth and Castro Streets. (Courtesy of the Noe Valley Archives.)

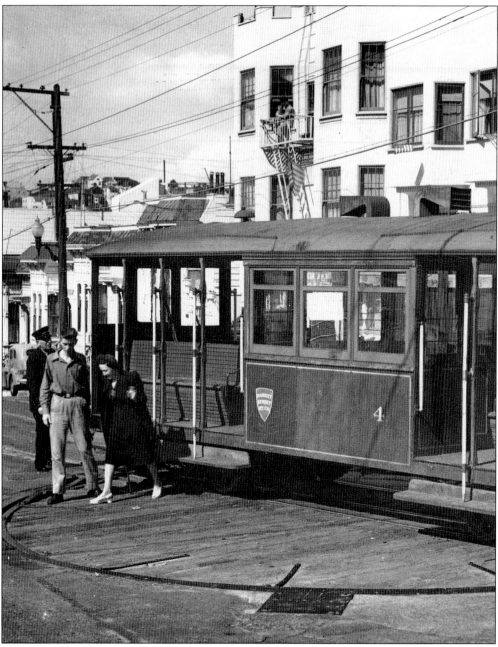

Passengers alight from the cable car at the end of the line, the turntable at Twenty-sixth and Castro Streets. (Courtesy of the Noe Valley Archives.)

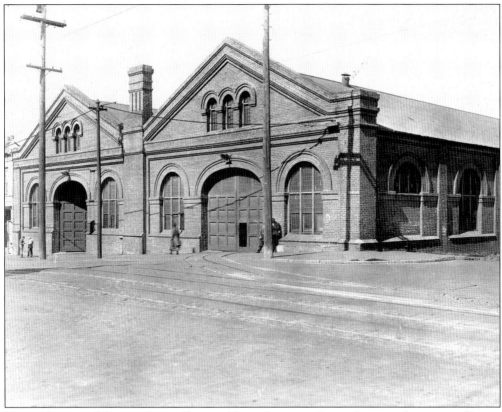

This early view of the two Castro Street cable car barns on Castro Street at the corner of Jersey Street was taken on a blustery August day in 1921. The Market Street Railway Company abandoned the property in 1941, and it became a Safeway market in about 1943. Safeway had earlier operated a store a block north at the corner of Twenty-fourth Street. At the turn of the 21st century, the barn on the left was the Walgreen's drugstore and the site of the barn on the right was a parking lot. (Courtesy of the Noe Valley Archives.)

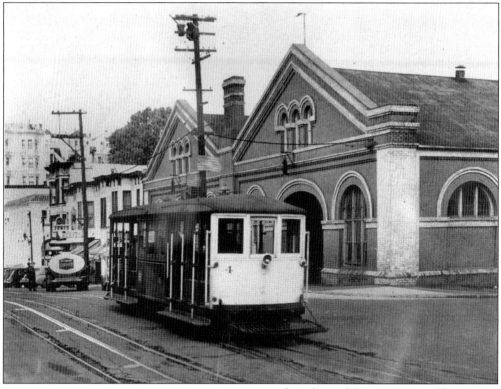

A white-fronted Castro Street cable car passes the car barns at the corner of Castro and Jersey Streets heading northbound from the turntable three blocks south. The line and the barns would be closed in 1941. With the building on the right torn town to make way for a parking lot, the site would be a Safeway market for three decades. Vacated in 1974, the building became the Little Bell Market in 1975 and a Walgreen's pharmacy in 1988. (Courtesy of the Noe Valley Archives.)

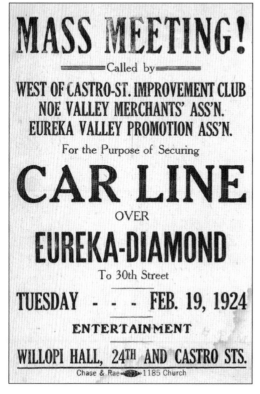

In 1924, Noe Valley residents joined with their neighbors in Eureka Valley to lobby the powers that be for a second car line across the hill from the Market Street transit corridor. It never happened. Entertainment was promised at the "Mass Meeting" in Willopi Hall. Among the sponsors, the Noe Valley Merchants Association still exists, as does the West of Castro Improvement Club, although it has been known as "East & West" of Castro since 1929. (Courtesy of the Noe Valley Archives.)

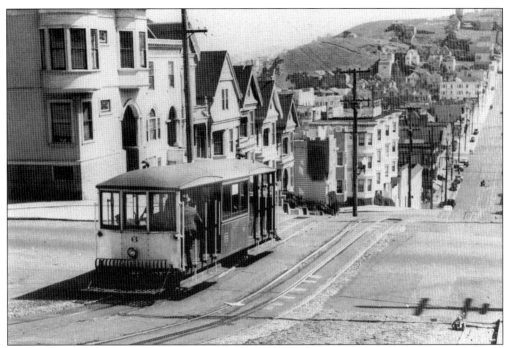

A southbound white-fronted Castro Street cable car passes Twenty-third Street as it climbs out of Noe Valley on the Castro Street line. A handful of passengers are aboard. The Castro Street cars would continue to "climb half way to the stars" only until 1941. (Courtesy of the Noe Valley Archives.)

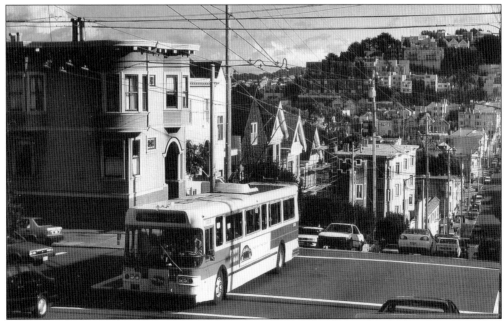

Today the Castro Street Hill is served by the Municipal Railway's Number 24 Divisadero electric buses. Most of the buildings that existed on these blocks in the 1940s are still present today. (Photo by Bill Yenne.)

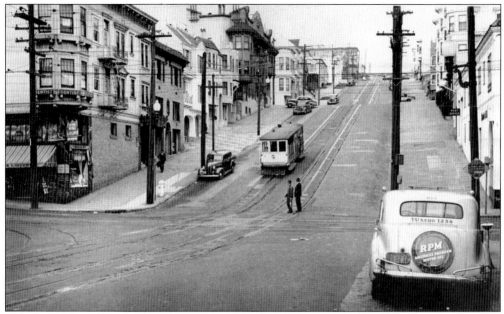

A white-fronted Castro Street cable car approaches Twenty-fourth Street as it reaches the commercial heart of Noe Valley, c. 1938. The intersection has changed little in the ensuing decades, although the stop signs have long since been superseded by a traffic light. (Courtesy of the Noe Valley Archives.)

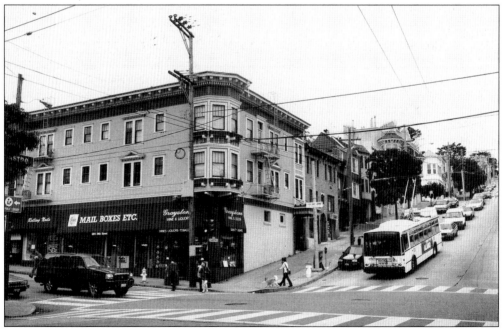

This is the intersection of Castro Street and Twenty-fourth Street as it appears today. The colorful cable cars were removed from the Castro Street line, which is now served by the Municipal Railway's Number 24 Divisadero electric bus. The Number 24 continues for several miles past the old cable car turntable that was four short blocks south of this point. (Photo by Bill Yenne.)

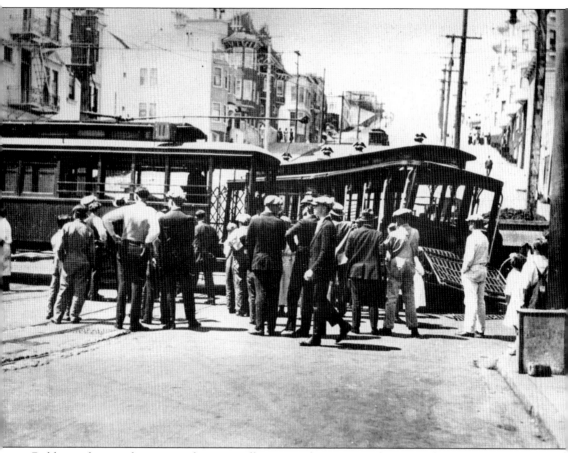

Rubberneckers gather to gawk at a collision at the corner of Twenty-fourth Street and Castro Street in the 1920s. The eastbound Number 11 Mission and Twenty-fourth Street electric car (left) apparently struck the southbound Castro Street Cable Car in the intersection. It is interesting to see how similar the electric trolleys were to the cable cars in their basic design. The Number 11 streetcar ran until January 15, 1949. When the line was converted to bus service, it was designated as the Number 11 Hoffman. (Courtesy of the Noe Valley Archives.)

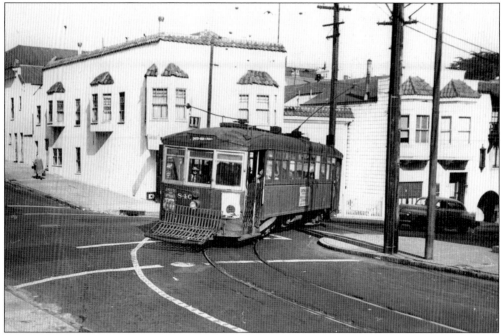

The westbound Number 11 Mission and Twenty-fourth Street electric car makes the turn from Twenty-second Street to Chattanooga Street. It will pass in front of the Edison School and make a right turn onto Twenty-fourth Street for its final run up the hill to Hoffman Avenue. (Courtesy of the Noe Valley Archives.)

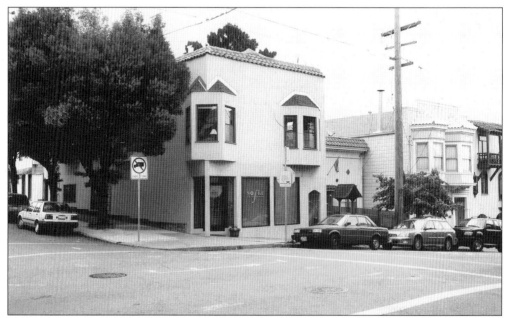

The intersection of Twenty-second Street and Chattanooga Street is much quieter today than it was in the clattering, clanging days of the old Number 11 Mission and Twenty-fourth Street electric car. The trees lining the street also add a great deal to the ambience of the corner. (Photo by Bill Yenne.)

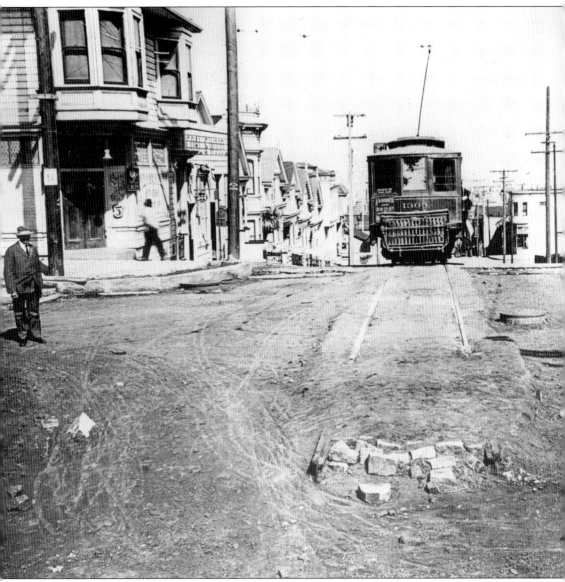

The terminus of the Number 11 Mission and Twenty-fourth Street electric car line on Twenty-fourth Street at Hoffman Avenue was still a work in progress in August 1916. Paving stones were being pulled out in preparation for pouring concrete. Passengers at the end of the line could nip into the corner grocery to buy California wine for a nickel. The Number 11 streetcar ran until January 15, 1949. When the line was converted to bus service, it was designated as the Number 11 Hoffman. (Courtesy of the Noe Valley Archives.)

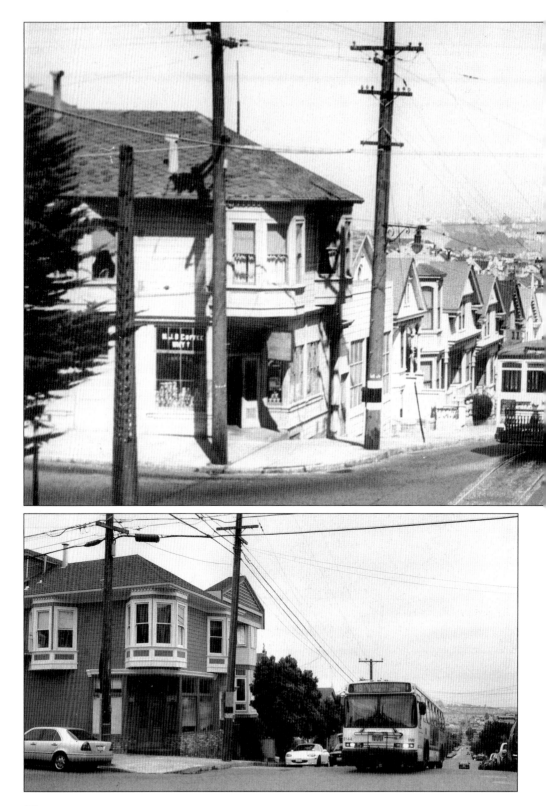

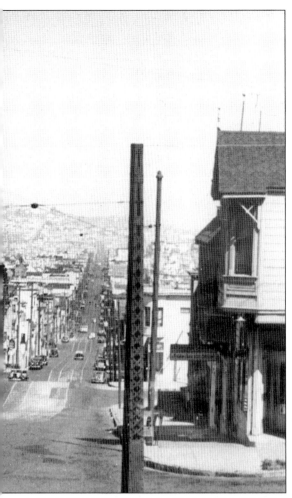

LEFT: The westbound Number 11 Mission and Twenty-fourth Street electric car reaches the end of the line on a warm spring day in 1948. This is a California Comfort car, built in the Market Street Railway's own Elkton shops. With the exception of the model years of the automobiles, Twenty-fourth Street has changed little. Note that there is another Number 11 car in the distance, outbound near Diamond Street. (Courtesy of the Noe Valley Archives.)

OPPOSITE, BELOW: The Municipal Railway's Number 48 Quintara diesel bus now serves the Twenty-fourth Street and Hoffman Avenue intersection. It does not stop, but rather continues across the hills to West Portal and beyond. The building on the corner is still there, but the storefront is no longer a store. (Photo by Bill Yenne.)

BELOW: An electric streetcar, possibly the Richland Avenue shuttle, makes its way through Noe Valley, advertising Acme Beer. Brewed at the large brewery at Fulton and Webster Streets, Acme was the most popular beer in California in the late 1940s. (Courtesy of the Noe Valley Archives.)

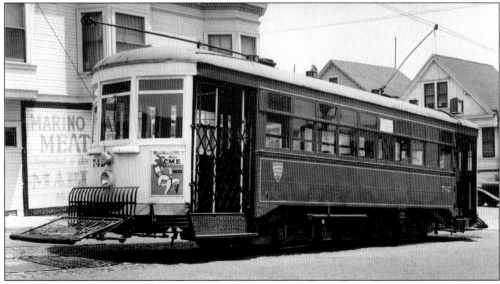

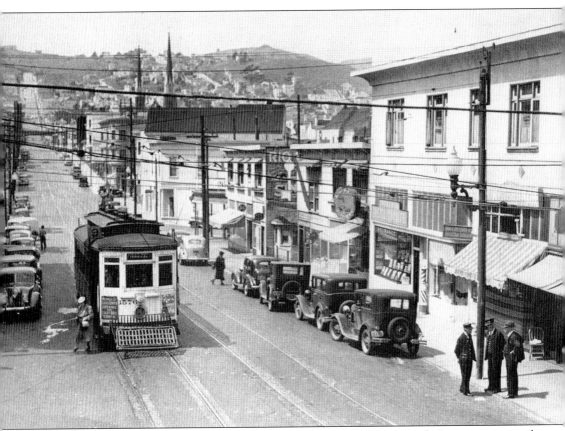

The Number 9 electric street car disembarks a passenger on Twenty-ninth Street just west of Mission, *c.* 1939. This line began at Noe Street and crossed the southeastern corner of Noe Valley. In the background, we can see the spires of St. Paul's Church and the slopes of Red Rock Hill beyond. (Courtesy of the Noe Valley Archives.)

OPPOSITE, ABOVE: Construction crews can be seen here at the corner of Twenty-second and Church Streets in July 1916 working on the Municipal Railway line that would bring the J-Church streetcars into Noe Valley. The Market Street Railway's Number 11 streetcar made its southbound turn toward Twenty-fourth Street just one short block east of this intersection. (Courtesy of the Noe Valley Archives.)

OPPOSITE, BELOW: The view at the corner of Twenty-second and Church Streets today is much the same as it was when the J-Church trolleys started running through the back yards in 1917. Today, however, the J-Church is the only rail service to reach Noe Valley. (Photo by Bill Yenne.)

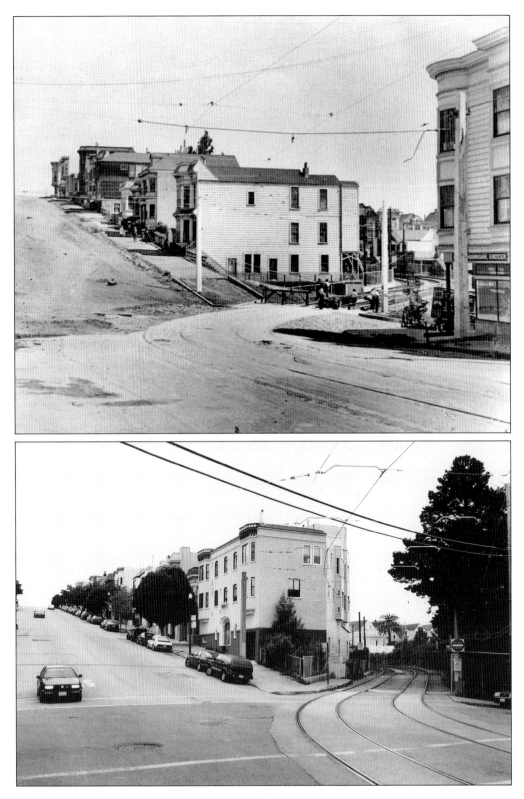

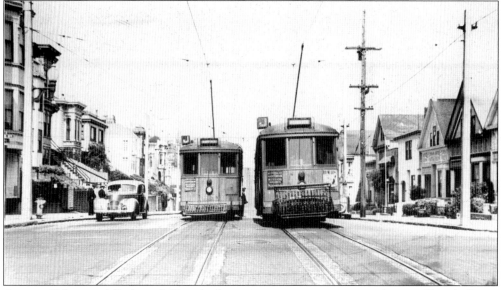

A pair of Municipal Railway J-Church electric streetcars pass one another on Church Street near the intersection with Twenty-third Street, c. 1940. They run along the most level north-south street in Noe Valley. (Courtesy of the Noe Valley Archives.)

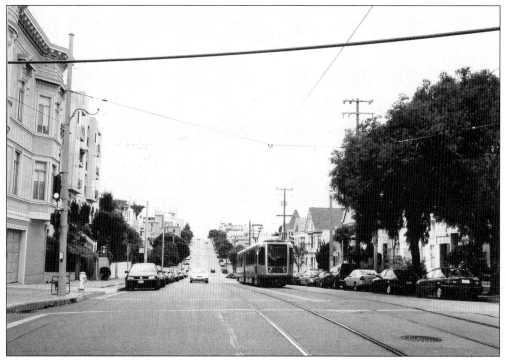

Here is the San Francisco Municipal Railway J-Church streetcar line at Church Street near Twenty-third Street as it appears today. (Photo by Bill Yenne.)

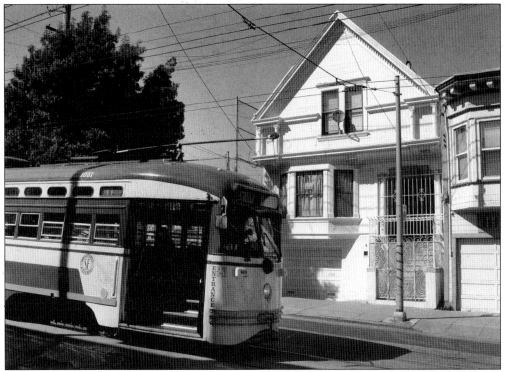

Were it not for the satellite dish on the Victorian in the background, this scene on Thirtieth Street near Church Street could have occurred at any time during the last half of the 20th century. The Municipal Railway acquired the PCC cars between 1948 and 1962 for use on all of the street car lines throughout the city. They would serve as the city's primary trolley system for more than a quarter-century, and today they still run as a featured part of the Municipal Railway's Historic Street Car program. The initials PCC stood for the Electric Railway Presidents' Conference Committee, which undertook an industry-wide cooperative research program aimed at designing a universal street car that could be used on trolley lines in cities throughout the United States. (Photo by Bill Yenne.)

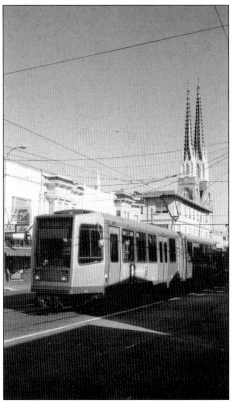

The San Francisco Municipal Railway began acquiring the Italian-made Breda LRV-2 street cars in the 1990s to replace Boeing Vertol cars that were ordered in the late 1970s. This J-Church Breda is seen near Twenty-ninth Street, with the spires of St. Paul's Church visible in the background. (Photo by Bill Yenne.)

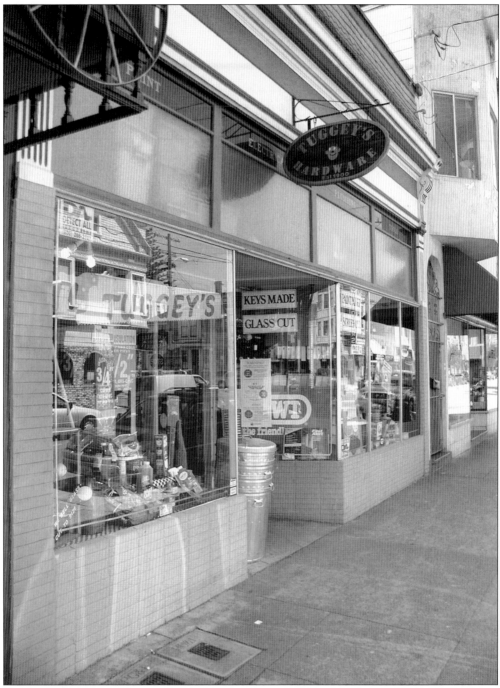

Founded in 1900 on Twenty-fourth Street just east of Sanchez Street, Tuggey's Hardware greeted the 21st century as the oldest storefront business in Noe Valley. Gene Tuggey sold the company to former employee Bob Giovannoli in the 1940s. Bob passed away in 1995, but the business is managed by his son Denny Giovannoli. (Photo by Bill Yenne.)

Three

A VISIT TO THE VALLEY

In the following pages, we take a historic stroll through various parts of Noe Valley. We begin with a westward walk along the commercial corridor on Twenty-fourth Street, then branch out to the outlying areas. We close this chapter with a look at the public schools in Noe Valley.

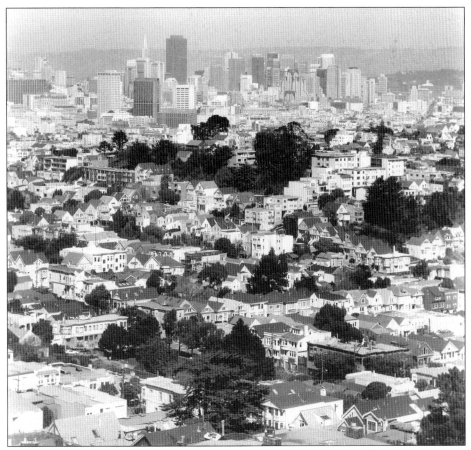

Compare this contemporary panoramic view from Diamond Heights to the one on page 4 that was taken in 1938. Except for the larger trees, Noe Valley has changed only slightly, while the downtown San Francisco skyline has changed considerably. (Photo by Bill Yenne.)

"Forward Noe Valley" read the banners carried by the school crossing guards from St. Philip's School celebrating their neighborhood cleanup campaign. The date is April 3, 1941, and the place is Twenty-fourth Street just east of Sanchez Street. Behind them on Twenty-fourth Street, the marquee of the Noe Theater on the right and a Number 11 street car are visible. (Courtesy of the Noe Valley Archives.)

Looking west along Twenty-fourth Street toward Sanchez Street today, this view shows most of the same buildings that lined these blocks in 1941. In the next block, however, the scene is different. The Noe Theater is gone, and Bell Market was built in 1968. (Photo by Bill Yenne.)

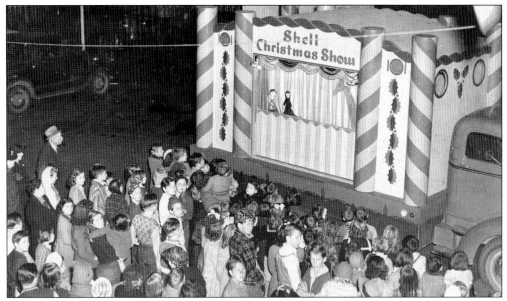

A Christmas puppet show is held in the 1940s at Johnny McCarthy's Shell gas station on the former site of the Vicksburg Theater on Twenty-fourth Street. Known as McCarthy's Super Service through 1960, it was Stan's Shell in the 1960s, and simply Shell during the 1970s. During the 1980s, it became Dan's Shell. By the 1990s, Dan first dropped his affiliation with Shell, then stopped selling gasoline entirely in order to concentrate on automotive repair. At the turn of the century, the property was acquired as a parking lot for the Noe Valley Ministry. (Courtesy of the Noe Valley Archives.)

During the 1920s, the Vicksburg Theater occupied a site on Twenty-fourth Street between Vicksburg and Sanchez Streets. It is believed that the Vicksburg was the first theater in Noe Valley to show motion pictures. The screen faced the street and patrons had to duck under it to get to their seats. The building was eventually torn down in to make way for Noe Valley's first gas station. (Courtesy of the Noe Valley Archives.)

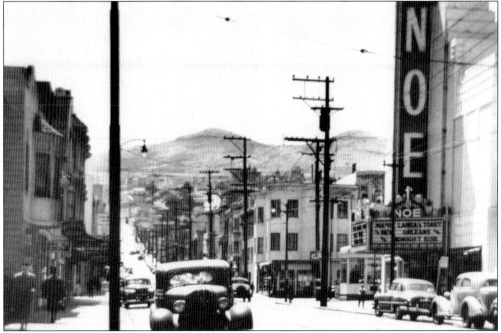

In this *c.* 1954 view looking west along Twenty-fourth Street toward the intersection with Noe Street, the Noe Theater is the dominant landmark in Noe Valley. The films playing date to 1949 and 1950, but the Chevrolet parked in front of the theater is a 1950 model. (Courtesy of the Noe Valley Archives.)

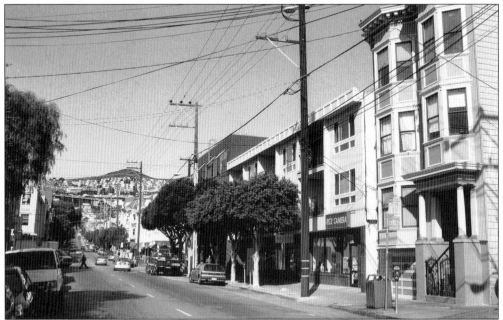

Today the view looking west along Twenty-fourth Street toward the intersection with Noe Street includes mostly new buildings. The same of course is true of Twin Peaks in the distance. As late as the 1950s, Twin Peaks was mainly open space. In the decades following, this would change dramatically. (Photo by Bill Yenne.)

The foyer of the Noe Theater on Twenty-fourth Street is pictured here in January 1943. (Courtesy of the Noe Valley Archives.)

This is a rare look inside the Noe Theater on Twenty-fourth Street as it would have appeared from the stage in January 1943. (Courtesy of the Noe Valley Archives.)

Here is the glamorous stage at the Noe Theater. The first film to play at the Noe when it opened in 1937 was *Old Hutch* with Wallace Beery and Cecelia Parker. (Courtesy of the Noe Valley Archives.)

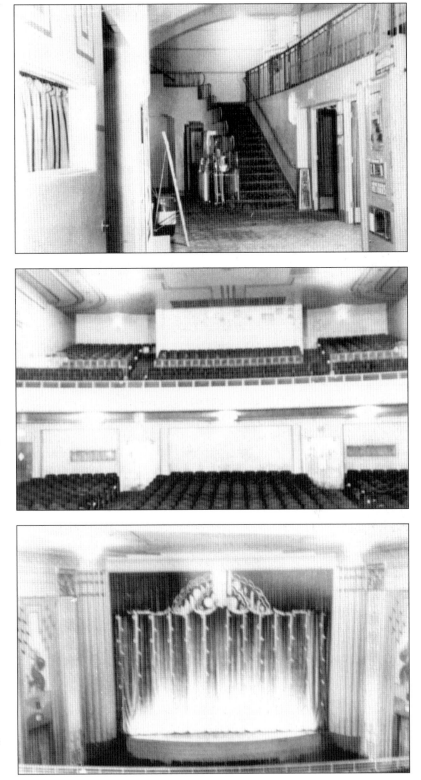

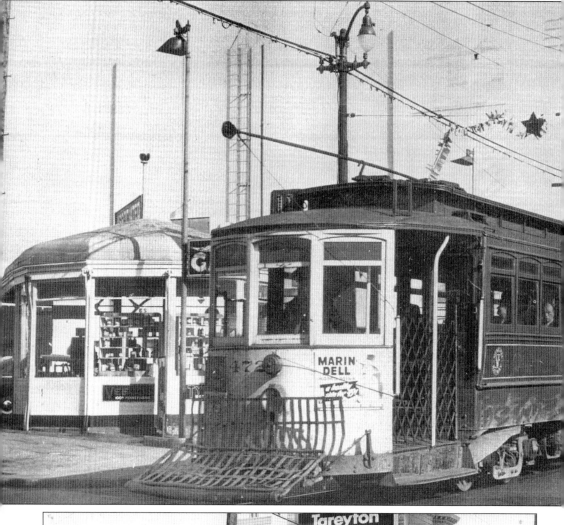

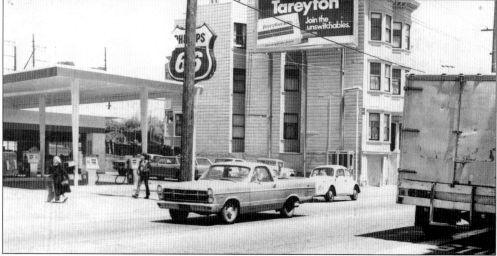

LEFT: Looking east from Noe Street c. 1948, this view shows Twenty-fourth Street decked out for the Christmas season. The Noe Valley Merchants' Association still decorates Twenty-fourth Street for the holidays each year. Also seen in this photograph are a Number 11 Hoffman, Charles Schroyer's Associated (later Flying A) Service Station, and, of course, the Noe Theater. (Courtesy of the Noe Valley Archives.)

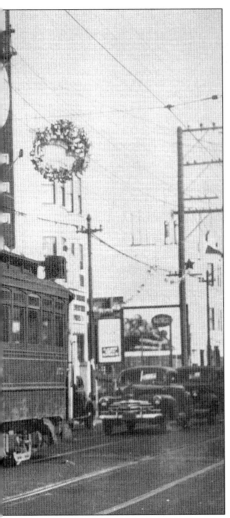

OPPOSITE, BELOW: In the mid-1960s, Schroyer's Flying A service station became Rich's Phillips's 66. By 1974, when this photograph was taken, it had become Larry's Phillips's 66. It would close as a gas station two years later. (Courtesy of the Noe Valley Archives.)

BELOW: Today, a building with a bank and two stories of residences above occupies the site at Twenty-fourth and Noe Streets that was a gas station for much of the 20th century. The last gas station closed here in 1976, but the first bank, Olympic Savings, would not open its doors for three years. Since that time, the bank has gone through a succession of name changes. (Photo by Bill Yenne.)

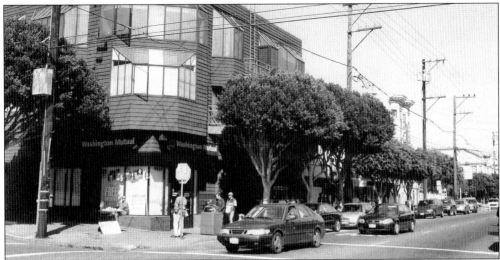

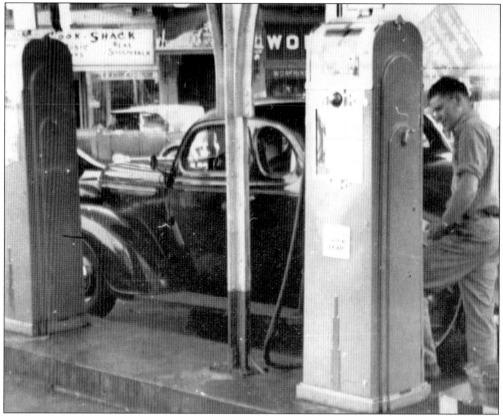

Pete Watson pumps gas at Charles Schroyer's Flying A service station. From the 1930s through the mid-1960s, the station anchored the corner of Twenty-fourth and Noe Streets. Across the street is the Cook Shack, which would later be known as X-From-Noe and later as Herb's Hamburger House. To the right is Worthington's drug store. (Courtesy of Harry Aleo.)

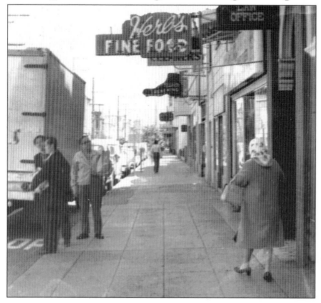

Two longtime icons on Twenty-fourth Street were Mission Shoe Renewing and Herb's Fine Foods, both pictured here in a view looking east along Twenty-fourth Street, c.1974. Helen and Arthur Weinschenk bought the shoe shop after World War II, and when Arthur died on Easter Sunday in 1964, Helen ran the shop by herself for the next 13 years. She was one of the most popular shopkeepers on Twenty-fourth Street. "Do a little extra for the customer," she has said. "It can't hurt. Do something nice and it all comes back." (Courtesy of the Noe Valley Archives.)

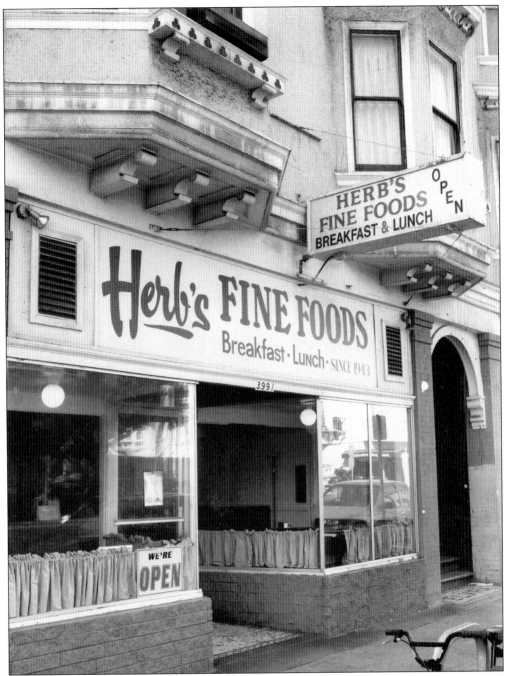

Herb's Fine Foods at 3991 Twenty-fourth Street is one of Noe Valley's signature locations and one of the oldest of the classic old-fashioned lunch counters in San Francisco. I was started by Cyril Saunders in 1943 as a soda fountain. Cyril eventually named his business X-From-Noe, because it was across the street from the Noe Theater. In 1945 it was acquired by Herb and Margaret Gaines, who renamed it, in 1953, Herb's Hamburger House. Herb later settled on calling it Herb's Fine Foods, the name by which it is still legendary. Herb operated his lunch counter until 1974, when he sold the business to Sam Kawas. (Photo by Bill Yenne.)

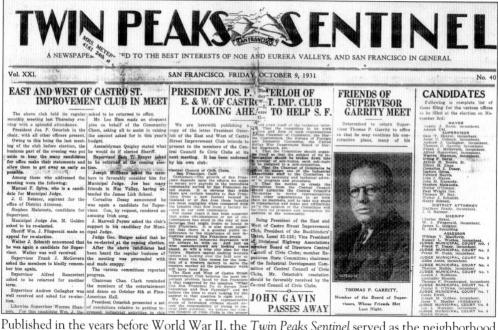

Published in the years before World War II, the *Twin Peaks Sentinel* served as the neighborhood newspaper for Noe Valley and Eureka Valley. Since then, the *Sentinel* went away, and the two valleys drifted apart. Noe Valley's current neighborhood paper, the *Noe Valley Voice* began in May 1977. (Courtesy of the Noe Valley Archives.)

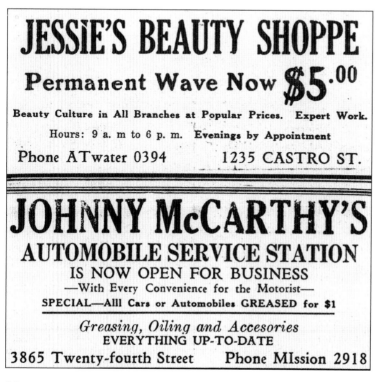

These are early advertisements for Noe Valley merchants in the *Twin Peaks Sentinel* neighborhood newspaper. Johnny McCarthy would later be affiliated with Shell Oil Company. As Dan's, this service station would be an automotive repair site nearly to the end of the 20th century. (Courtesy of the Noe Valley Archives.)

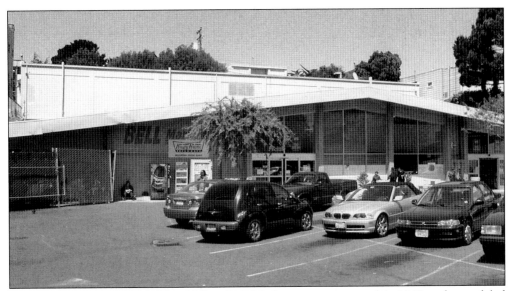

The largest grocery store in Noe Valley, Bell Market was constructed in 1968 and remodeled several times since. The site has had an interesting history. Through the early 1950s, the City and County of San Francisco Disaster and Civil Defense Corps occupied part of the site in a relatively new structure built in the 1940s. The Civil Defense Corps left in 1956, and in 1958 this building became a tavern called the Valley Cavern. Next door was an auto repair establishment owned by Ramon Urbina, who had previously worked as a mechanic at Morrison Buick across the hill in Eureka Valley. In 1959 it was known as Mike and Jim's Garage. (Photo by Bill Yenne.)

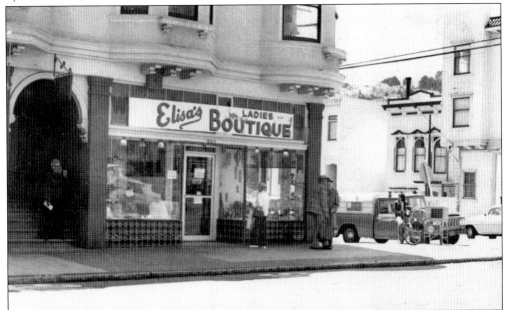

This is the south side of the intersection at Twenty-fourth and Noe Streets as it appeared c. 1974. For much of the 20th century Worthington's occupied the site. Elisa's Ladies Boutique was here through the 1970s, and at the turn of the century Starbuck's operated a coffee shop here. (Courtesy of the Noe Valley Archives.)

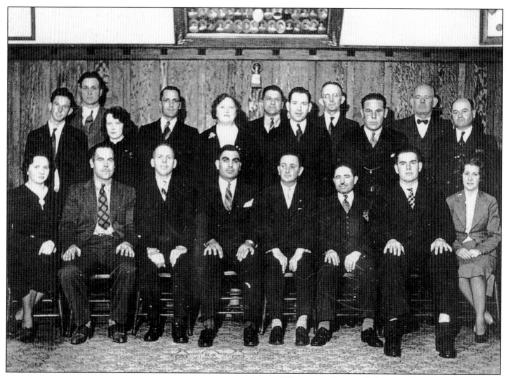

The members of the Noe Valley Merchants' Association are pictured in the late 1920s. In the back row, Billy Ebert is on the far left, Nandi Sordelli is fourth from left, John Aleo is sixth from left, Clarence Ritter is fourth from right, Ozzie Leiss is third from right, Johnny McCarthy is second from right, and John Smallback is on the far right. In the front row, Gene Tuggey of Tuggey's Hardware is third from left, Tony Tedesco is fourth from left, Tom Lagos is third from right, and Roy Gadd is second from right. (Courtesy of the Noe Valley Archives.)

Late in the 1930s, the Noe Valley Merchants' Association introduced their own trading stamps. These were a common sight through the early 1940s. (Courtesy of the Noe Valley Archives.)

PROGRESSIVE WHIST

GIVEN BY

"Boost the Valley"

Noe Valley Merchants
SOCIAL CLUB

FINN HALL

425 Hoffman Avenue, at 24th St. End of No. 11 Car Line

Valuable Prizes on Display at 3925-24th Street

Tickets 25 Cents [Tickets For Sale Here] Game Starts at 8:15

124

Among the activities pursued by the Noe Valley Merchants' Association in their ongoing effort to "Boost the Valley" was Progressive Whist. The games were held regularly at the Finnish Hall on Hoffman Avenue. A quarter got you in the door, and "Lady Luck" took you the rest of the way. The hall still stands, the Merchants' Association is still active, but, alas, Progressive Whist is just a fond memory. (Courtesy of the Noe Valley Archives.)

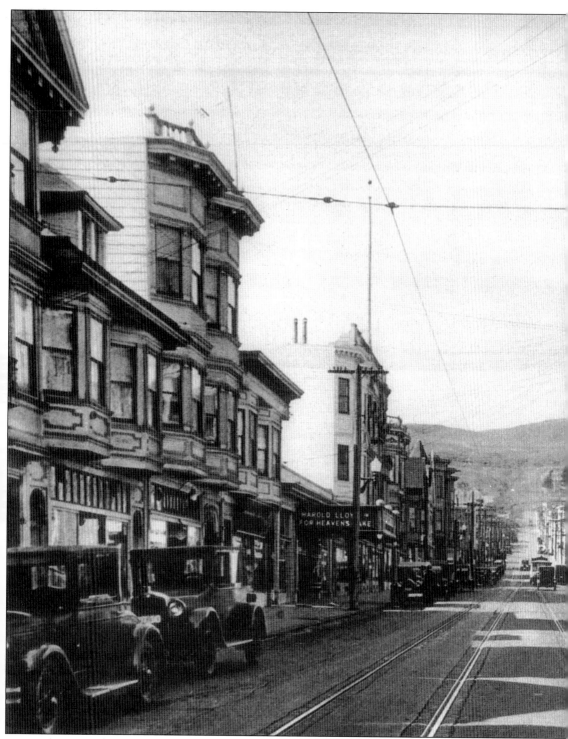

The south side of Twenty-fourth Street, looking west from Noe Street, is pictured in 1926. Note that Twin Peaks was still open range. (Courtesy of the Noe Valley Archives.)

This is the north side of Twenty-fourth Street, looking west from Noe Street, in 1926. The site of the Palmer Market was later a bank, and was the Zephyr real estate office at the beginning of the 21st century. (Courtesy of the Noe Valley Archives.)

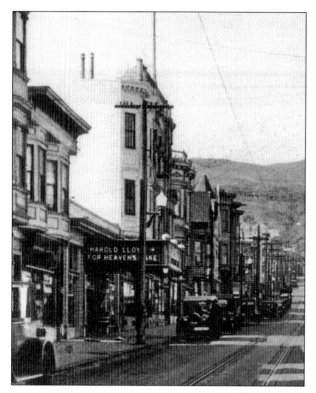

This detail view from the south side of Twenty-fourth Street west of Noe Street in 1926 includes the Palmer Theater, which was showing a Harold Lloyd picture that was released that year. It featured Lloyd as an "uptown boy" opposite Jobyna Ralston as a "downtown girl." The Palmer Theater opened in about 1923 and occupied this site until World War II. After the war, the Noe Valley Garage would be located here through 1963. In 1964 the Surf Super grocery took over the location, sharing space with Reno's Meat Market until 1988, when the Thrifty Jr. (Rite Aid after 1996) drug store moved in. (Courtesy of the Noe Valley Archives.)

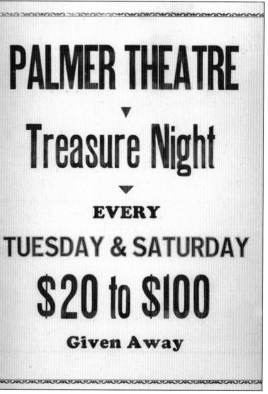

Every Tuesday and Saturday, the Palmer Theater would host its Treasure Night. Not only could you enjoy a moving picture, you stood to win real cash. (Courtesy of the Noe Valley Archives.)

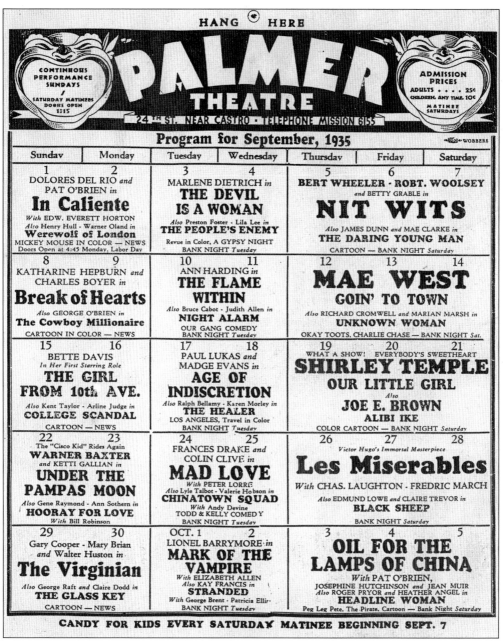

HANG HERE

PALMER THEATRE

24TH ST. NEAR CASTRO · TELEPHONE MISSION 6155

CONTINUOUS PERFORMANCE SUNDAYS
SATURDAY MATINEES DOORS OPEN 1:15

ADMISSION PRICES
ADULTS · · · · 25¢
CHILDREN, ANY TIME 10¢
MATINEE SATURDAYS

Program for September, 1935

Sunday	Monday	Tuesday	Wednesday	Thursday	Friday	Saturday
1 DOLORES DEL RIO *and* PAT O'BRIEN *in* **In Caliente** *With* EDW. EVERETT HORTON *Also* Henry Hull · Warner Oland *in* **Werewolf of London** MICKEY MOUSE IN COLOR — NEWS Doors Open at 4:45 Monday, Labor Day	**2**	**3** MARLENE DIETRICH *in* **THE DEVIL IS A WOMAN** *Also* Preston Foster · Lila Lee *in* **THE PEOPLE'S ENEMY** Revue in Color, A GYPSY NIGHT BANK NIGHT *Tuesday*	**4**	**5** BERT WHEELER · ROBT. WOOLSEY *and* BETTY GRABLE *in* **NIT WITS** *Also* JAMES DUNN *and* MAE CLARKE *in* **THE DARING YOUNG MAN** CARTOON — BANK NIGHT *Saturday*	**6**	**7**
8 KATHARINE HEPBURN *and* CHARLES BOYER *in* **Break of Hearts** *Also* GEORGE O'BRIEN *in* **The Cowboy Millionaire** CARTOON IN COLOR — NEWS	**9**	**10** ANN HARDING *in* **THE FLAME WITHIN** *Also* Bruce Cabot · Judith Allen *in* **NIGHT ALARM** OUR GANG COMEDY BANK NIGHT *Tuesday*	**11**	**12** **MAE WEST** GOIN' TO TOWN *Also* RICHARD CROMWELL *and* MARIAN MARSH *in* **UNKNOWN WOMAN** OKAY TOOTS, CHARLIE CHASE — BANK NIGHT *Sat.*	**13**	**14**
15 BETTE DAVIS *In Her First Starring Role* **THE GIRL FROM 10th AVE.** *Also* Kent Taylor · Arline Judge *in* **COLLEGE SCANDAL** CARTOON — NEWS	**16**	**17** PAUL LUKAS *and* MADGE EVANS *in* **AGE OF INDISCRETION** *Also* Ralph Bellamy · Karen Morley *in* **THE HEALER** LOS ANGELES, Travel in Color BANK NIGHT *Tuesday*	**18**	**19** WHAT A SHOW! EVERYBODY'S SWEETHEART **SHIRLEY TEMPLE** OUR LITTLE GIRL *Also* **JOE E. BROWN** ALIBI IKE COLOR CARTOON — BANK NIGHT *Saturday*	**20**	**21**
22 The "Cisco Kid" Rides Again **WARNER BAXTER** *and* KETTI GALLIAN *in* **UNDER THE PAMPAS MOON** *Also* Gene Raymond · Ann Sothern *in* **HOORAY FOR LOVE** *With* Bill Robinson	**23**	**24** FRANCES DRAKE *and* COLIN CLIVE *in* **MAD LOVE** *With* PETER LORRE *Also* Lyle Talbot · Valerie Hobson *in* **CHINATOWN SQUAD** *With* Andy Devine TODD & KELLY COMEDY BANK NIGHT *Tuesday*	**25**	**26** Victor Hugo's Immortal Masterpiece **Les Miserables** *With* CHAS. LAUGHTON · FREDRIC MARCH *Also* EDMUND LOWE *and* CLAIRE TREVOR *in* **BLACK SHEEP** BANK NIGHT *Saturday*	**27**	**28**
29 Gary Cooper · Mary Brian *and* Walter Huston *in* **The Virginian** *Also* George Raft *and* Claire Dodd *in* **THE GLASS KEY** CARTOON — NEWS	**30**	OCT. 1 LIONEL BARRYMORE *in* **MARK OF THE VAMPIRE** *With* ELIZABETH ALLEN *Also* KAY FRANCIS *in* **STRANDED** *With* George Brent · Patricia Ellis BANK NIGHT *Tuesday*	**2**	**3** **OIL FOR THE LAMPS OF CHINA** *With* PAT O'BRIEN, JOSEPHINE HUTCHINSON *and* JEAN MUIR *Also* ROGER PRYOR *and* HEATHER ANGEL *in* **HEADLINE WOMAN** Peg Leg Pete, The Pirate, Cartoon — Bank Night *Saturday*	**4**	**5**

CANDY FOR KIDS EVERY SATURDAY MATINEE BEGINNING SEPT. 7

The Palmer Theater's program for September 1935 gives us a cross-section of what was available to movie-goers back then. Pictures changed every two or three days so that one could see as many movies in a month—or more—as can be seen at a modern multiplex. Double features were standard and there was usually a cartoon and often a newsreel. (Courtesy of Harry Aleo.)

This rare photo shows the Acme Nickelodeon Theater, which was located a half-dozen doors west of the Palmer Theater on the same block. It predated the Palmer by several years, but was gone a few years after this photograph was taken in about 1927. Now the U.S. Post Office, the site was home to the fondly remembered Glen Five & Ten variety store through much of the latter 20th century. (Courtesy of the Noe Valley Archives.)

Across the street from the site of the Palmer, Noe Valley Auto Works and J.R. Hubbard's Selecta Auto Body occupy a building where businesses have catered to the motoring trade for nearly a century. Vince Hogan's popular Valley Tavern occupies the property that was home to such legendary 20th-century pubs as Finnegan's Wake and the Rat & Raven. (Photo by Bill Yenne.)

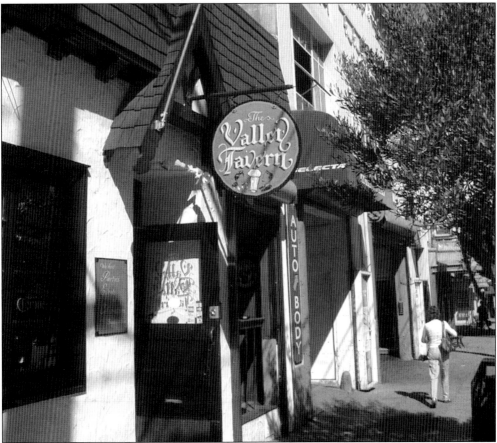

Located at 4061 Twenty-fourth Street, Willopi Hall was the center of civic life in Noe Valley throughout the first half of the 20th century. Built in 1909, it was the scene of various neighborhood organization meetings from the Noe Valley Merchants to the East & West of Castro Street Improvement Club, both of which are still active. Founded in 1904 as just "West of Castro," the latter group became "East & West" in 1929 and is Noe Valley's oldest neighborhood group. Its members were responsible for convincing San Francisco to pave Noe Valley's streets. Willopi Hall was condemned in 1961 and purchased by neighborhood merchants, who sold the site to the City at cost for use as a public parking lot. (Courtesy of the Noe Valley Archives.)

The Twenty-fourth and Noe Garage was actually located in the middle of the block, between Castro and Noe Streets. Today it is still in business and known as Noe Valley Auto Works. (Courtesy of the Noe Valley Archives.)

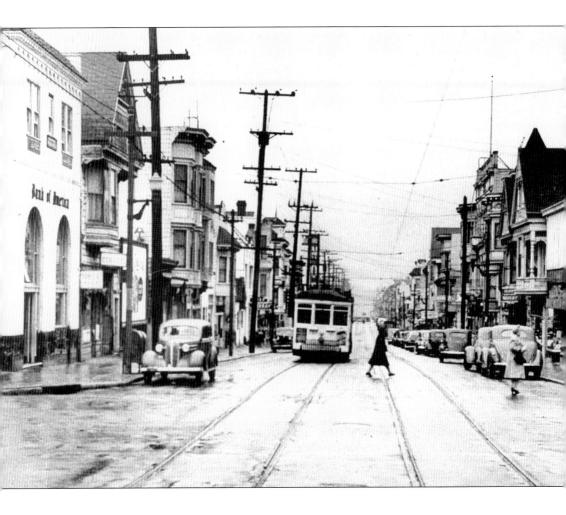

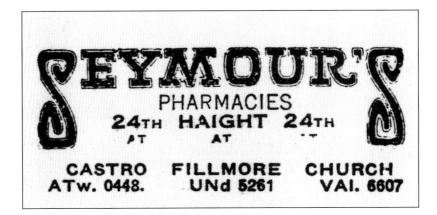

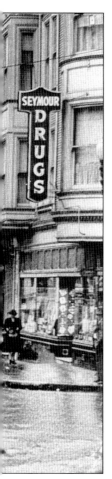

LEFT: This view is looking east on Twenty-fourth Street from Castro Street on a rainy day in December 1944. Bank of America was still located in the building on the far left at the turn of the 21st century. The marquee of the Noe Theater is visible a block away, just above the Number 11 Hoffman trolley that rattles toward the intersection. Cross traffic had to stop; the street car had the right of way. (Courtesy of the Noe Valley Archives.)

OPPOSITE, BELOW: Seymour's Pharmacies once had two drug stores on Twenty-fourth Street in Noe Valley, including one in the picture on the left. This was the prestigious location of Twenty-fourth Street and Castro where the two transit lines crossed. A drug store would still be located at this site until the 1980s. (Courtesy of the Noe Valley Archives.)

BELOW: The corner of Twenty-fourth Street at Castro Street would be familiar today to a time traveler from the middle of the 20th century. Bank of America still anchors the northeast corner in the same building. Across the street, Seymour's became Castro Drugs. The sign remains, although the site has since become the Cotton Basics clothing store. Down the street, trees now shade the old Victorian storefronts. (Photo by Bill Yenne.)

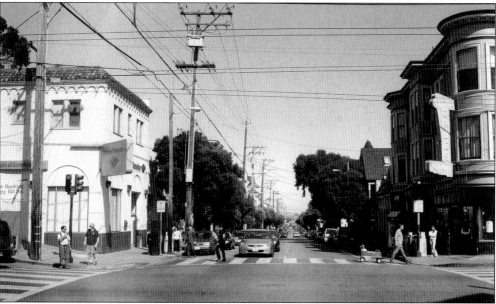

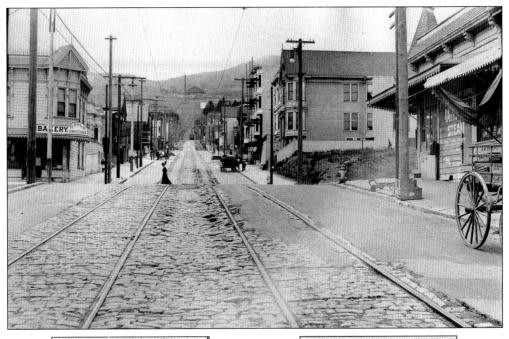

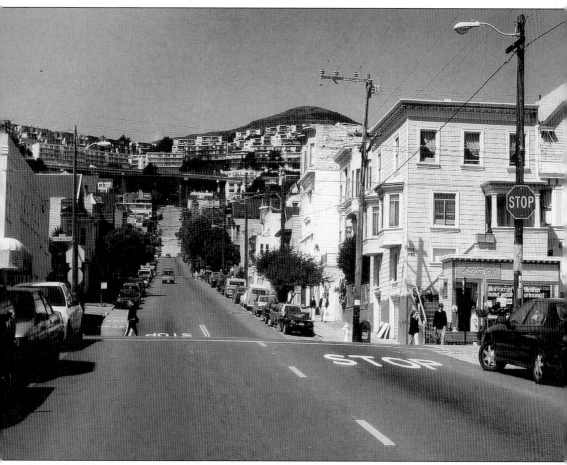

Several of the Victorian structures seen here at the corner of Twenty-fourth Street and Diamond Street are still there, but the one that housed Kolb's Bakery is gone. So too are the trolley tracks, but Twin Peaks is now cloaked with residences. (Photo by Bill Yenne.)

OPPOSITE, ABOVE: Looking west along Twenty-fourth Street toward the corner of Diamond Street in June 1909, one can see the Number 11 Hoffman street car at the top of the hill. Above, the slopes of Twin Peaks remain undeveloped. The sides of the streets had been paved, but the area around the trolley tacks was still cobblestones. (Courtesy of author's collection.)

OPPOSITE, BELOW, LEFT: Everything you could want, and right here in Noe Valley! Cotter & Nordfelt stood ready to build you a home, while just next door, a businessman could have lunch for 50¢. This part of the 4100 block is still home to several eateries, but today, none are "open all night" nor do they "serve meals at all hours." (Courtesy of the Noe Valley Archives.)

OPPOSITE, BELOW, RIGHT: Of the Noe Valley businesses that advertised in the 1930s, most would go by the wayside. Dr. Nast hung up his stethoscope long ago, but Tuggey's hardware went on to celebrate its centennial as it entered the 21st century. (Courtesy of the Noe Valley Archives.)

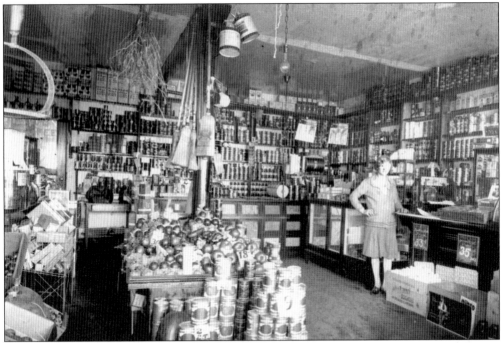

The interior of John and Lena Aleo's market at 820 Diamond Street appears here in 1928. The well-stocked grocery store offered canned goods and fresh produce, as well as fresh eggs and brooms. Familiar brands include Kellogg's Corn Flakes and San Francisco–roasted MJB Coffee. (Courtesy of Harry Aleo.)

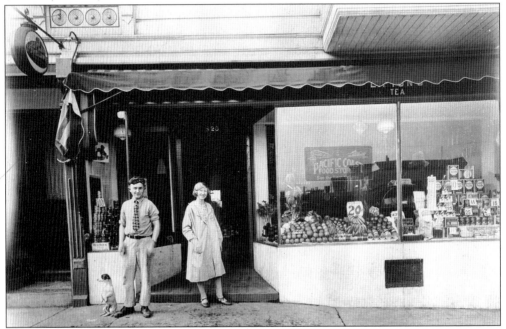

Lena Aleo, with her brother Mike Bruce and dog Fanny, poses in front of Aleo's Market at 820 Diamond Street, a few doors south of Twenty-fourth Street. (Courtesy of the Noe Valley Archives.)

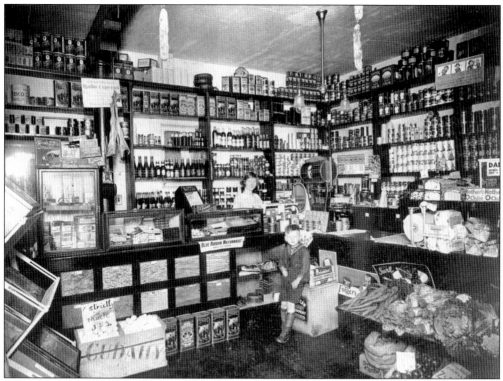

The Aleos added some glass cases to the top of the counter, which Lena Aleo is standing behind in this 1929 photograph. Familiar products include Quaker Oats and Heinz Ketchup. Mother's Cake was displayed adjacent to Dad's Oatmeal Cookies. There was certainly plenty of olive oil. (Courtesy of Harry Aleo.)

John Aleo, on a ladder in 1928, paints the building that housed Aleo's Market at 820 Diamond Street. (Courtesy of the Noe Valley Archives.)

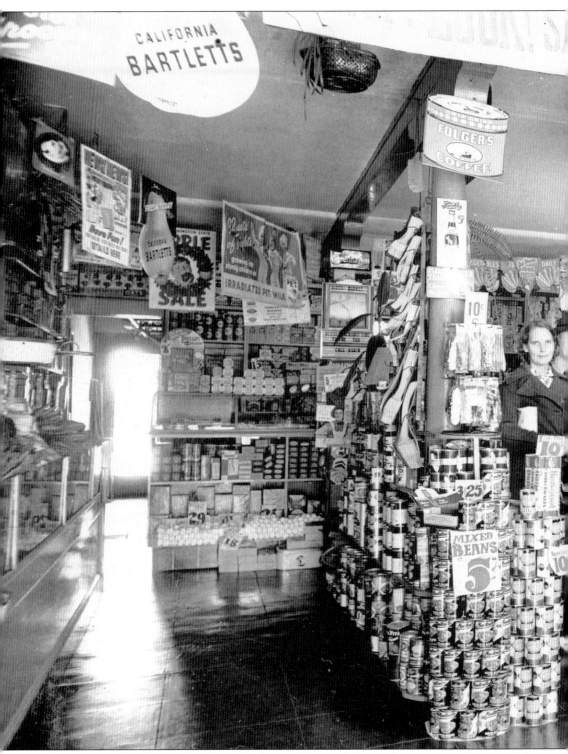

This photograph taken inside Aleo's Market on Diamond Street shows how sophisticated the point-of-sale material had become in the decade since 1929. From left to right are Ione Doss,

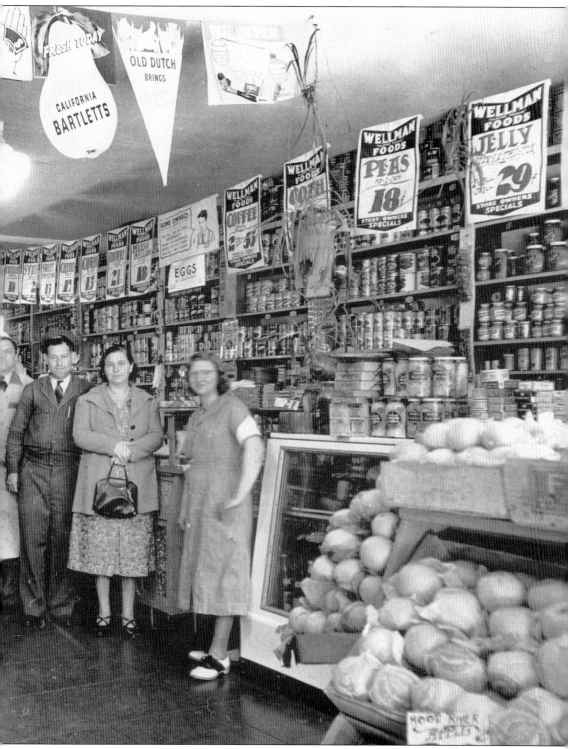

Bob Doss, John Aleo, Aldo Borello, an unidentified customer, and Lena Aleo. Lena's brother Mike hand lettered the prices on the signs. (Courtesy of the Noe Valley Archives.)

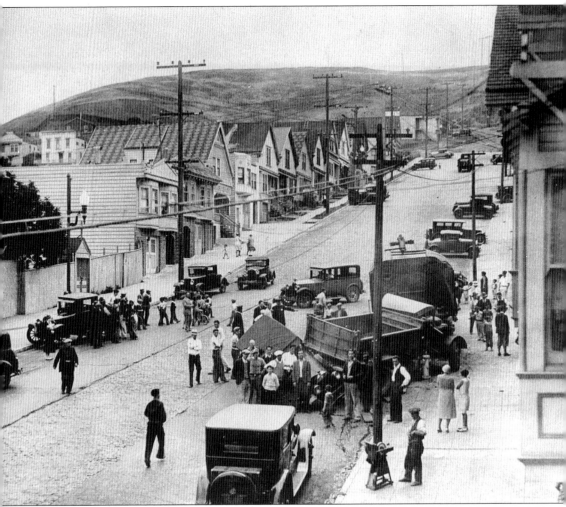

A bit of excitement on a normally quiet block—Noe Valley residents gather to try to figure out exactly what happened in this 1930 mishap on Army Street up the hill from Sanchez Street. Apparently the dump truck was backing off the sidewalk just as someone was turning into a garage. The truck barely missed the fire plug. The man in the foreground is setting up to sharpen knives. (Courtesy of the Noe Valley Archives.)

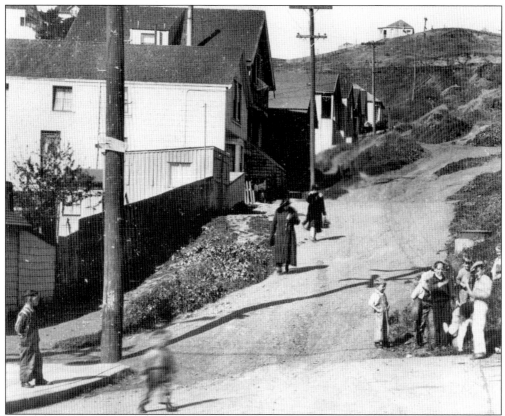

A lively group of young people gather at the corner of Castro Street and Valley Street, c. 1919. At that time, the last block of Valley Street remained unpaved. (Courtesy of the Noe Valley Archives.)

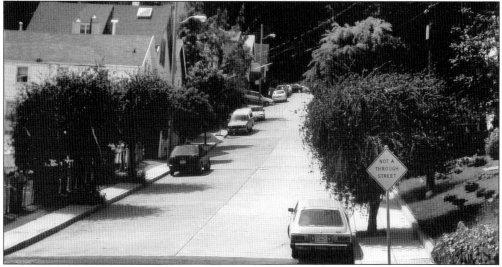

The last block of Valley Street has now been paved, but several of the houses seen in the 1919 photograph at the top of the page are still there. Today there is more foliage, but fewer kids on the street. (Photo by Bill Yenne.)

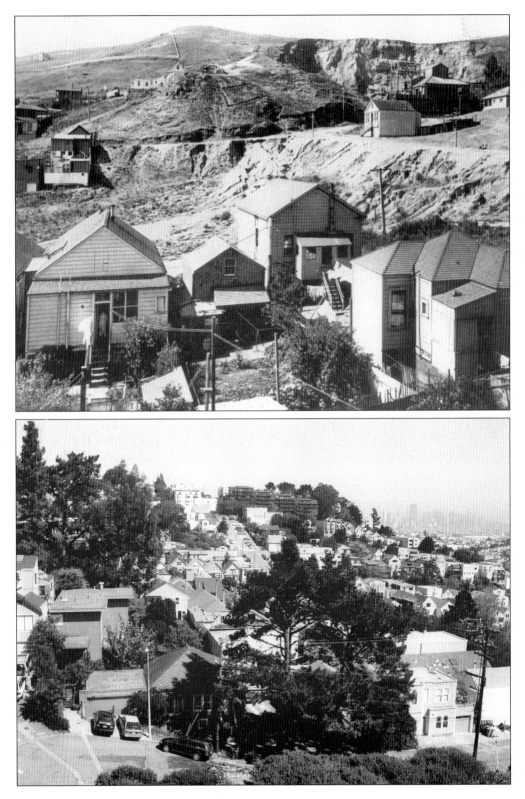

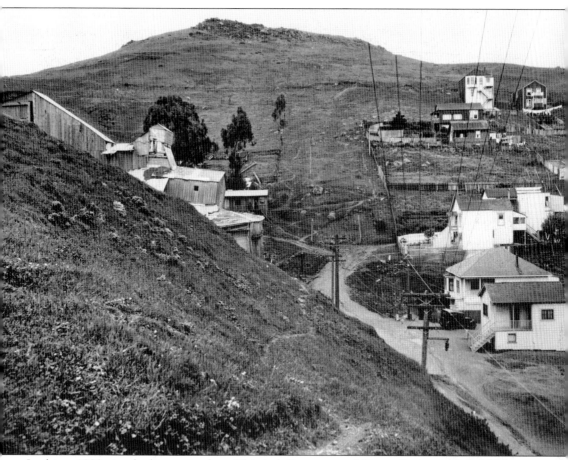

In this *c.* 1920 view looking west along Thirtieth Street toward Castro Street, with Gold Mine Hill beyond, the buildings of the old Gray Brothers quarry can be seen on the left. By this time, there were already quite a number of residences in this area at the foot of what had been Horner's Addition. A half-century later, Gold Mine Hill would be crowned with a massive residential development. (Courtesy of the Noe Valley Archives.)

OPPOSITE, ABOVE: At the turn of the century, the Gray Brothers quarry, seen on the upper right, supplied much of the cut stone used in construction within Noe Valley. This 1910 view looks south toward Billy Goat Hill from the vicinity of Day and Castro Streets. (Courtesy of the Noe Valley Archives.)

OPPOSITE, BELOW: In this image, one can see the view looking north toward the head of Thirtieth Street from the site of the Gray Brothers quarry as it appears today. The home with the pyramidal roof in the foreground may be the same one that appears in the photo from 1920 on the next page. (Photo by Bill Yenne.)

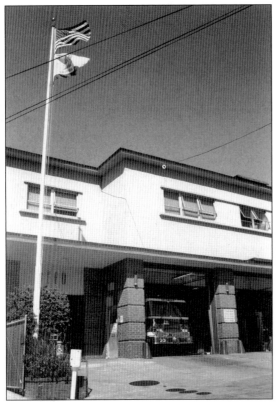

Opened on February 7, 1958, Noe Valley's newest fire station is located on Twenty-sixth Street between Church Street and Dolores Street. Today it is home to Truck Company 11 as well as Engine Company 11. The latter was designated Engine Company 13 until 1974. (Photo by Bill Yenne.)

The San Francisco Fire Department responds to a fire near the corner of Twenty-third and Diamond Streets. (Photo by Bill Yenne.)

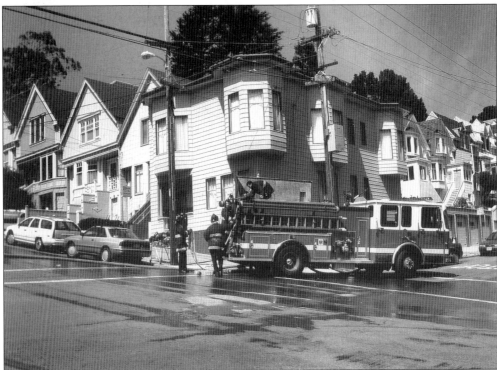

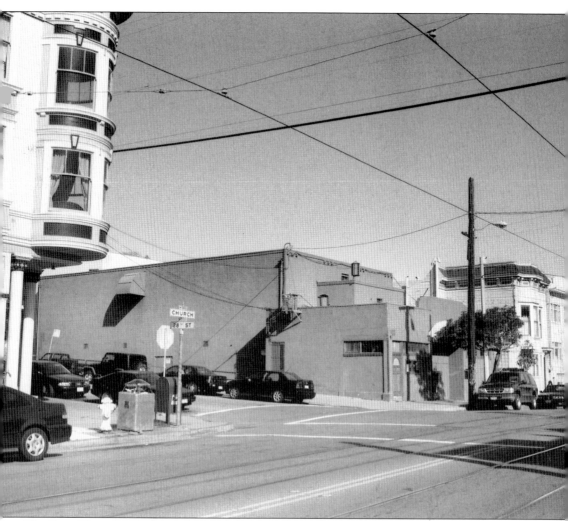

The Rita Theater on Church Street at Twenty-eighth Street (originally Vale Street) opened about 1916 and was known as the Empress. It became the Rita after World War II. Located in what then was a predominantly German section of Noe Valley, the theater originally featured German-language films but later switched to American movies. The only theater in the Church Street business district, the Rita flourished until around 1960. The building later was used as the Holiness Temple of Christ, and it became the Church at San Francisco in the early 1990s. It is the last surviving building in Noe Valley that is still configured as a movie theater. (Photo by Bill Yenne.)

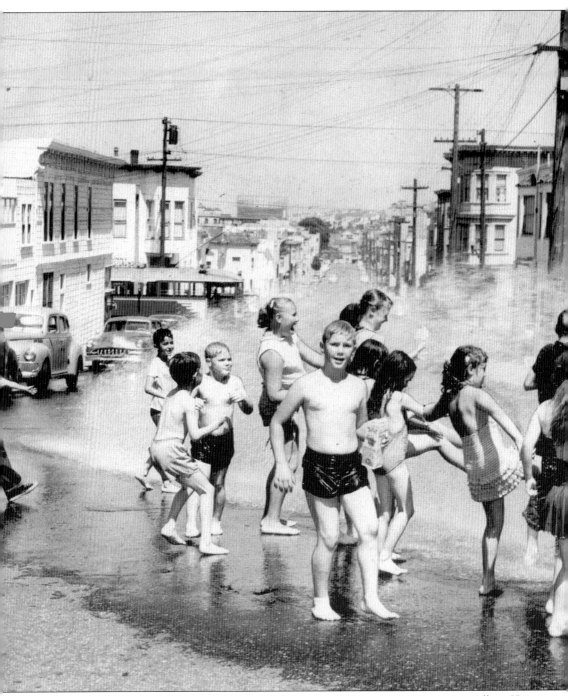

This hot day in Noe Valley, c. 1955, called for emergency measures. Lieutenant Albert Kaiser of San Francisco Fire Department Truck Company 11 at 315 Duncan Street ordered that the plug be pulled to cool off this group of Noe Valley youngsters. The firehouse opened in 1892 to house Engine 18, which was joined by Truck Company 11 in 1910. Engine 18 was later relocated, but Truck Company 11 would remain until 1958, when it moved to new quarters on Twenty-sixth Street. A northbound Municipal Railway J-Church streetcar

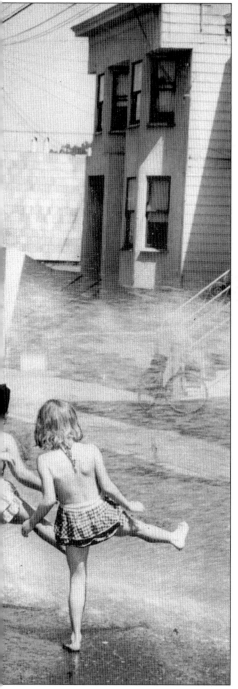

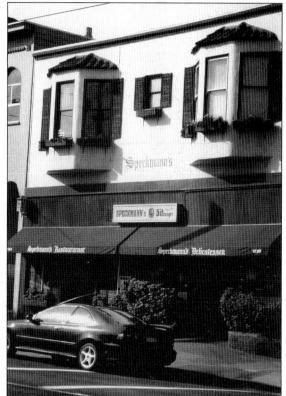

The venerable Speckmann's at the corner of Church and Duncan Streets was long one of Noe Valley's favorite restaurants and one of the San Francisco Bay Area's favorite German restaurants. Speckmann's German deli faced Church Street, and the entrance to the bierstube and restaurant was around the corner on Duncan Street. German immigrant Hans Speckmann opened his deli here in 1962 and added a kitchen three years later. In 1974, Speckmann's was acquired by Ebby and Peter Ullmann. A quarter-century later, their decision to retire and close Speckmann's sent a shockwave through Noe Valley. During their final week, at the end of April 2001, lines of people waiting for a table were around the block every night. (Photo by Bill Yenne.)

can be seen on Church Street in the background. The building that would later house Speckmann's is on the right on the corner of Church and Duncan Streets. (Courtesy of the Noe Valley Archives.)

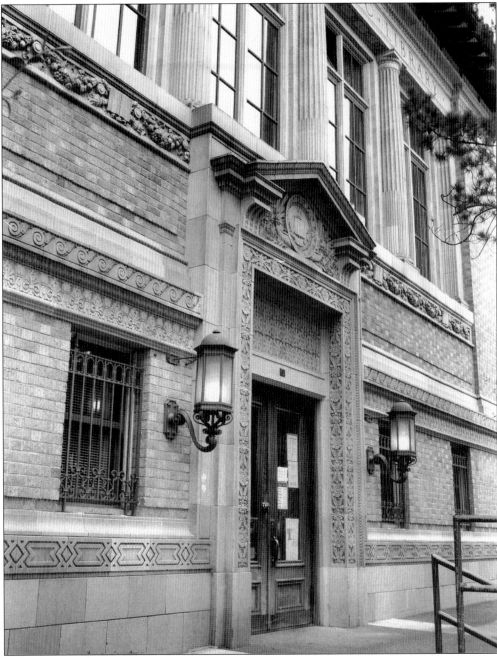

Designed by architect John Reid Jr., the Noe Valley Branch Library on Jersey Street was constructed with a portion of a grant from Andrew Carnegie that was given to the City in 1912. Completed in September 1916, it was the seventh in San Francisco's system of branch libraries. In 1987, this system reached a crisis when one-term mayor Art Agnos became notorious for his scheme to save money by closing branch libraries. Noe Valley's branch was on his hit list, but neighbors rallied and it was saved. In February 1992, Noe Valley's public library was renamed the Noe Valley/Sally Brunn Memorial Branch Library in honor of Sally Brunn, a longtime Noe Valley resident and library supporter who passed away in 1991. (Photo by Bill Yenne.)

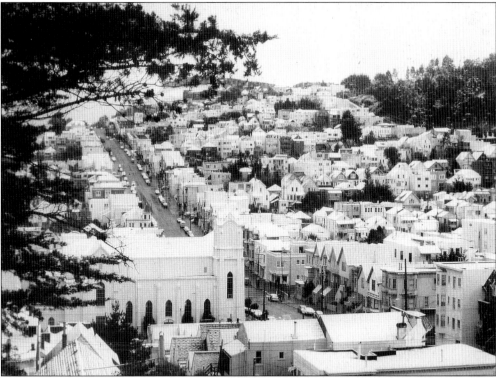

Noe Valley is a winter wonderland in the above photograph. The snowstorm of February 6, 1976, dropped three to four inches on Noe Valley and as much as half a foot on Twin Peaks. The snow on the street melted soon after daybreak, but it lingered in many Noe Valley backyards for several days. It was the most snow that San Francisco received at any time during the 20th century, and the most since the record storm of February 5, 1887. (Photo by Bill Yenne.)

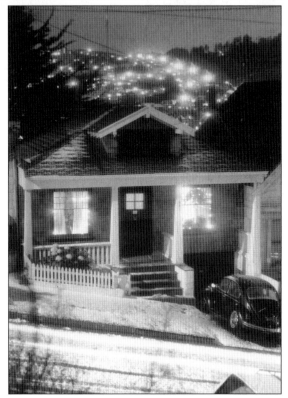

The owner of this 1910 cottage on Alvarado Street still had his Christmas lights up when the snow started falling in February 1976—so he plugged them back in! The snow brought joy to all those who didn't have to drive on the icy hills. All of the bus lines serving Noe Valley were halted overnight. (Photo by Bill Yenne.)

The towering, turreted, three-story, mixed-use building at the corner of Twenty-third and Douglass Streets was constructed in 1912 at a time when most of the east side of Douglass Street and the south side of Twenty-third Street were just vacant lots. The grocery store on the ground floor would be Wieger & Hagermann through 1933 and William Wieger alone until 1935. (Courtesy of the Noe Valley Archives.)

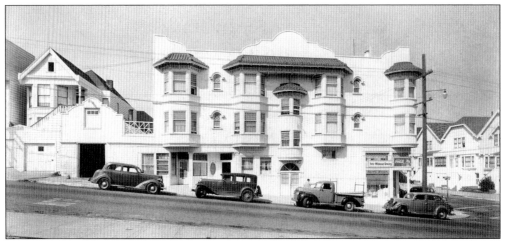

Peter Wilhusen bought the grocery at Twenty-third and Douglass Streets in 1941 from Bertha and Bernard Dinse, who had bought it from William Wieger in 1935. Wilhusen sold it to Norman Beber in 1955. (Courtesy of the Noe Valley Archives.)

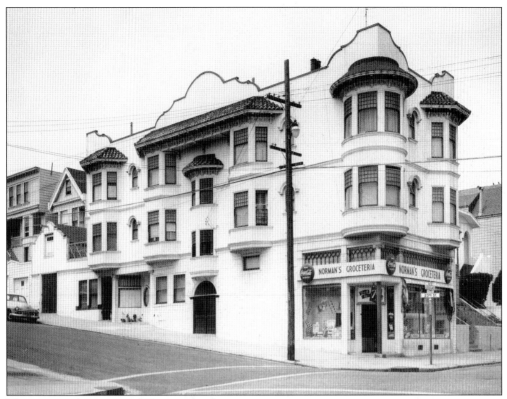

The store at the corner of Twenty-third and Douglass Streets became Norman's Groceteria in 1957 and remained as such until 1973, when it became the S&G Grocery. (Courtesy of the Noe Valley Archives.)

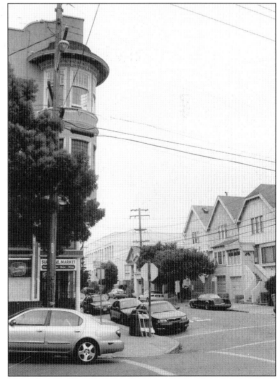

The S&G Grocery at the corner of Twenty-third and Douglass Streets became the Sunshine Market in 1982. Alvarado Elementary School, which opened in 1926, can be seen in the background. (Photo by Bill Yenne.)

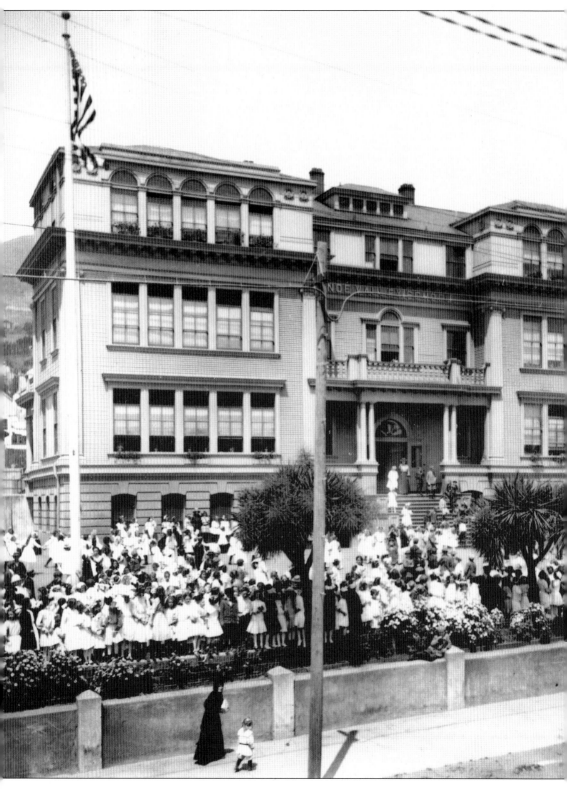

Opened in 1900, the Noe Valley School provided elementary education for kids throughout Noe Valley. And, by the looks of the picture at left, there were a lot of them. The large, four-story structure faced Douglass Street between Twenty-fourth Street and Elizabeth Street. A previous Noe Valley School had existed in a rented building at Noe and Jersey Streets. (Courtesy of the Noe Valley Archives.)

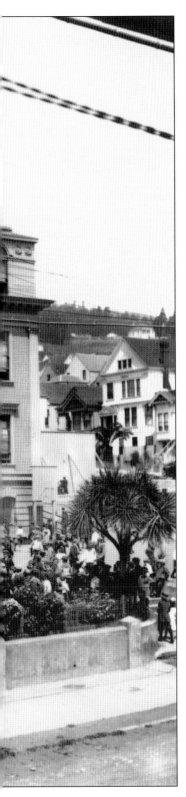

The Noe Valley School was closed in 1926 and demolished. The site has been a park ever since. The tennis and basketball courts known as "Noe Courts" are up on the hill at the back of the park, and a children's playground is located to the right of the bus shelter. In the background, several of the same houses on Elizabeth Street have overlooked the site since the school was here. (Photo by Bill Yenne.)

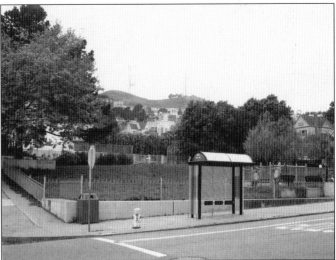

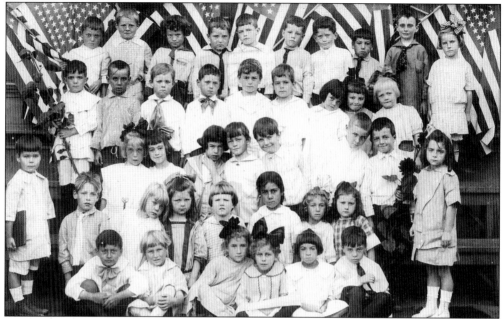

Noe Valley School students, perhaps first-graders, are pictured here in 1916. (Courtesy of the Noe Valley Archives.)

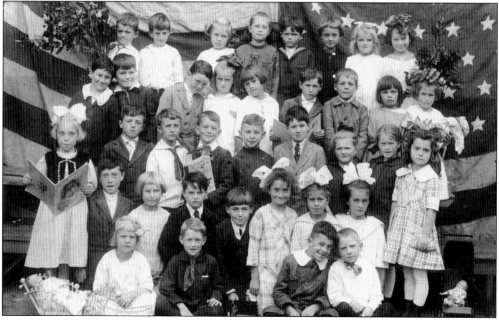

A year later, the same group of Noe Valley School children in the 1916 class picture at the top of the page, now probably second-graders, are ready to pose for 1917. The little girl in the right foreground is quite recognizable from the earlier photo. (Courtesy of the Noe Valley Archives.)

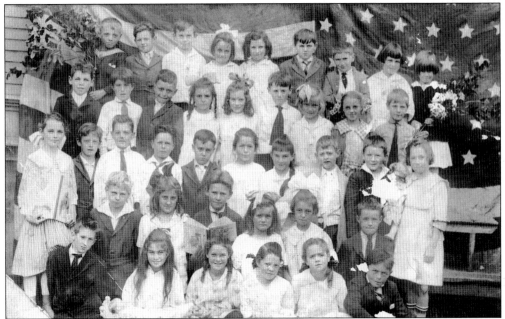

Students of the Noe Valley School's third grade in 1917 pose for their class picture. In the front row on the far right is Bill Fisher. Avis Root is first in the third row, while Dick MacCabe is third from left in the third row. Blanche Waters is on the far right in the third row. (Courtesy of the Noe Valley Archives.)

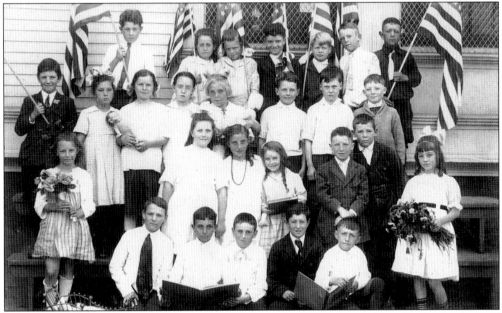

Students at the Noe Valley School pose for this 1919 class picture. Flags, flowers, books, and dolls were typically used as props in class pictures taken during this era. (Courtesy of the Noe Valley Archives.)

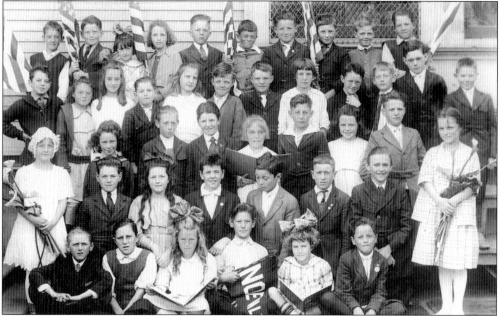

A Noe Valley School pennant appears in this class photo from 1920. These students look as though they are about ready to make the transition to junior high school. (Courtesy of the Noe Valley Archives.)

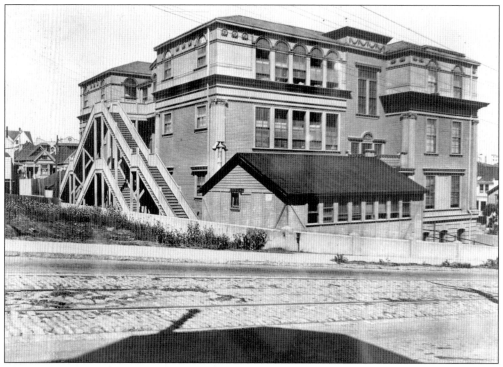

The southwest corner of the Noe Valley School, as seen from Twenty-fourth Street, is pictured *c.* 1920. Note the Number 11 Hoffman street car tracks. The school closed in 1926 and was replaced by the new Alvarado School. (Courtesy of the Noe Valley Archives.)

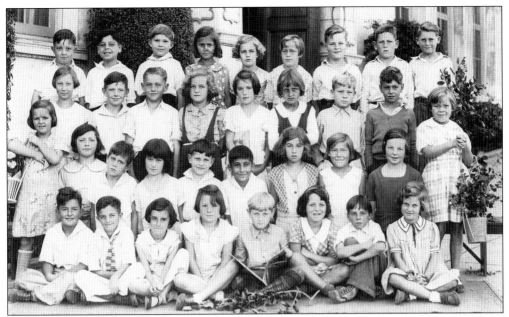

Students from the Alvarado School pose for this 1932 class picture. Located at the intersection of Douglass Street and Alvarado Street, the school had been serving Noe Valley students for six years when this picture was taken. (Courtesy of the Noe Valley Archives.)

Alvarado School was still one of the major public elementary schools in Noe Valley in the 21st century, although many of the students came from other neighborhoods. Beginning in the 1970s, the San Francisco Unified School District adopted the policy of sending most children outside their home neighborhoods for school. (Photo by Bill Yenne.)

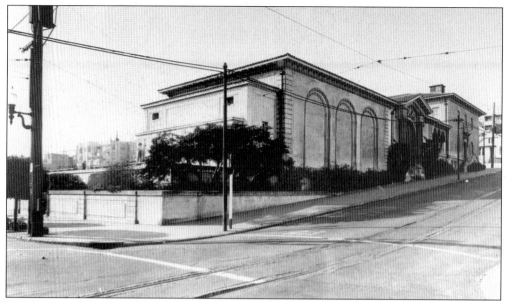

The Edison School on Twenty-second Street at Dolores Street opened in 1927 to serve elementary school students from the eastern edge of Noe Valley. The main building, seen here, was constructed in 1931. Many students traveled to Edison on the Number 11 Hoffman street car, whose tracks passed near the school's front door. A previous Edison Primary School was established at Church and Hill Streets in 1890. (Courtesy of the Noe Valley Archives.)

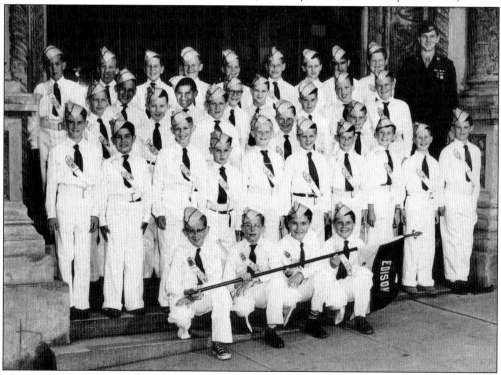

The crossing guard corps from Edison School smile proudly in their new uniforms in this 1956 photograph. (Courtesy of the Noe Valley Archives.)

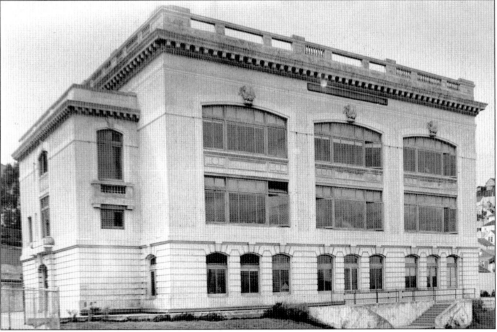

Named for pioneer San Francisco educator Kate Kennedy, this school was established in 1911 at Thirtieth and Noe Streets to serve elementary school students living in the southern part of Noe Valley. Kate Kennedy was the first female principal in California and a crusader for equal pay for women teachers. (Courtesy of the Noe Valley Archives.)

This group of young scholars were in Miss Mahoney's first-grade class at the Edison School in 1952. (Courtesy of the Noe Valley Archives.)

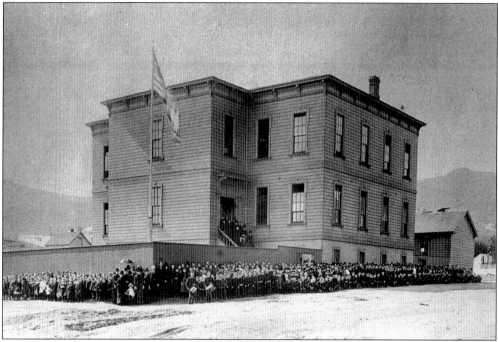

James Lick Grammar School is pictured here shortly after it opened in 1874. The view looks southwest from the corner of Twenty-fifth and Noe Streets, neither of which were yet paved. (Courtesy of the Noe Valley Archives.)

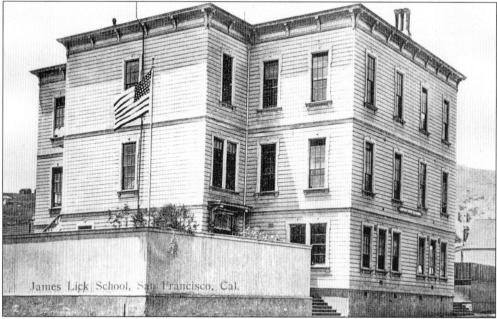

James Lick School, San Francisco, Cal.

This photo shows the James Lick Grammar School after it was rebuilt in the late 1880s. Substantial work has been done to the foundation, and a new chimney has replaced the previous brick one. (Courtesy of the Noe Valley Archives.)

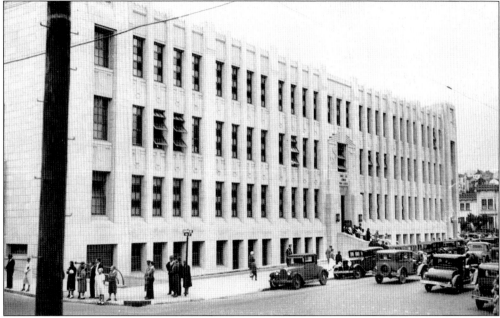

This photograph shows the present James Lick School building not long after it was completed in 1932. The photo was taken looking in northwesterly from the corner of Clipper Street and Noe Street. (Courtesy of the Noe Valley Archives.)

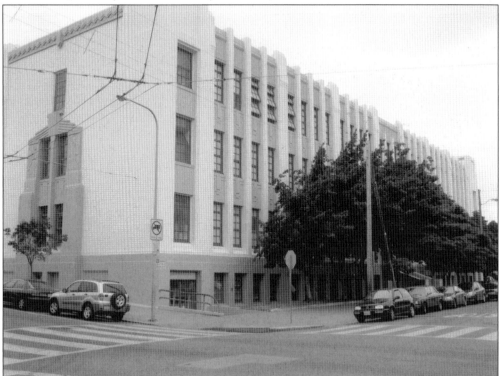

Pictured here is the school as it appeared seven decades later, with the addition of a line of trees. (Photo by Bill Yenne.)

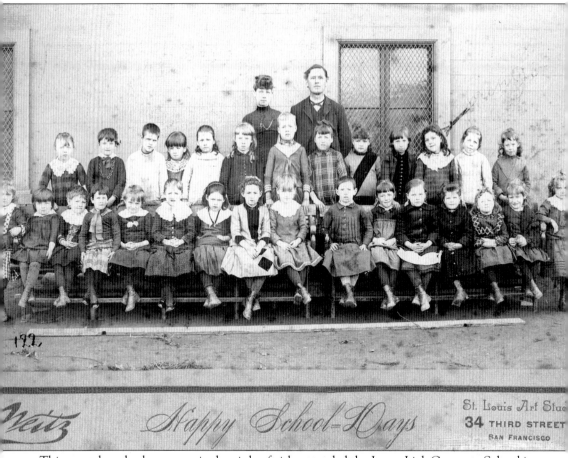

This second-grade class, comprised mainly of girls, attended the James Lick Grammar School in 1888. Josephine Drolett is the third from the right in the second row. (Courtesy of the Noe Valley Archives.)

This group of students photographed at the James Lick School in 1909 are probably the graduating class that year. (Courtesy of the Noe Valley Archives.)

Raymond Youngman graduated from the James Lick Grammar School on June 10, 1924. (Courtesy of the Noe Valley Archives.)

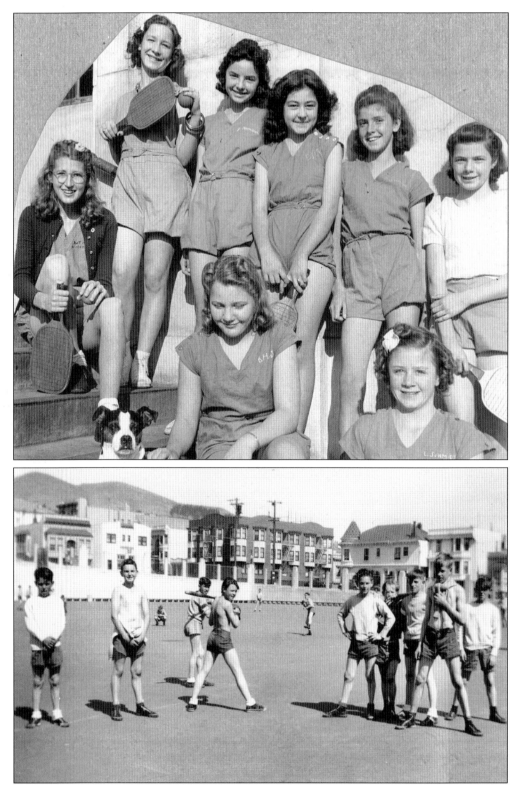

ABOVE: Coach Russell Cabot took this photograph of the 1939 James Lick School track team. Posing proudly in the foreground is the school's mascot, Coach Cabot's dog Skipper. (Courtesy of the Noe Valley Archives.)

OPPOSITE, ABOVE: When the young ladies of the James Lick School table tennis team posed for this informal portrait in 1940, Skipper the mascot also got into the act. (Courtesy of the Noe Valley Archives.)

OPPOSITE, BELOW: Coach Russell Cabot snapped this informal photograph of kids playing ball on the James Lick School playground in 1939. Many of the buildings in the background are recognizable today. (Courtesy of the Noe Valley Archives.)

The James Lick School basketball team won the city championship in 1938 for the third time in four years. (Courtesy of the Noe Valley Archives.)

JAMES LICK
JUNIOR HIGH SCHOOL
Be it Known that

Paul Kantus

having Completed the Course of Study prescribed for this
Junior High School is granted this

Certificate

by the Board of Education of the City and County
of San Francisco

Given on the 13th day of June 1940

PRINCIPAL

HOME ROOM TEACHER

Paul Kantus was a one of the students who graduated from James Lick Junior High School on June 13, 1940. (Courtesy of the Noe Valley Archives.)

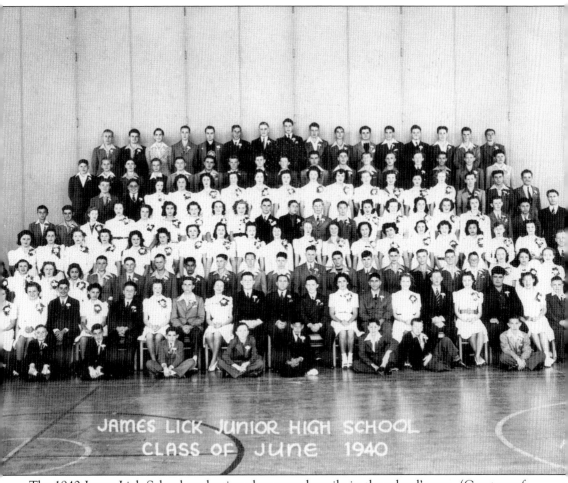

The 1940 James Lick School graduating class poses happily in the school's gym. (Courtesy of the Noe Valley Archives.)

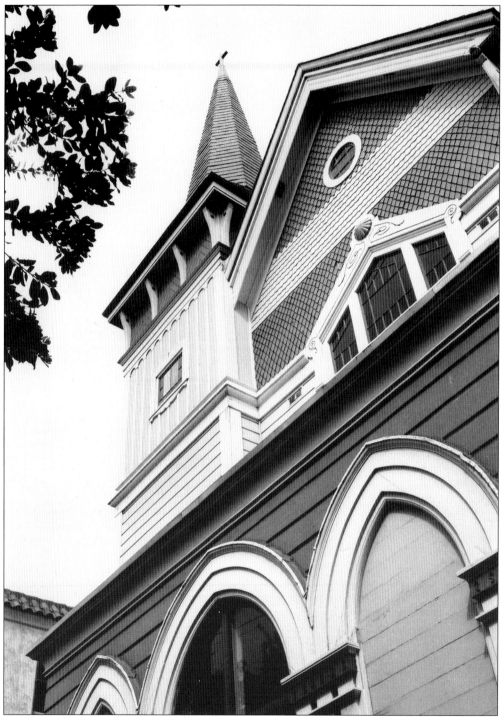

Dedicated in 1888 as the Lebanon Presbyterian Church, this church on Sanchez Street, near Elizabeth Street, has been home to the Noe Valley Ministry since 1977. The building also houses many neighborhood organizations and activities, including the neighborhood newspaper, the *Noe Valley Voice*. (Photo by Bill Yenne.)

Four

THE CHURCHES OF NOE VALLEY

Noe Valley has been home to many religious communities through the years. To the German-American and Irish-American Catholics who constituted a sizable proportion of Noe Valley's population in the early 20th century, the valley was divided between St. Philip's Parish to the north and St. Paul's Parish to the south. Meanwhile, the oldest church building standing today in Noe Valley is a Presbyterian church.

The Lebanon Presbyterian Church on Sanchez Street was completed in 1888 and dedicated on June 17 of that year, although its congregation had been worshipping in Noe Valley since 1881. A hand-pumped pipe organ was located here in 1903, but it was replaced in 1948 by a Moller Electric Organ.

In 1977, the Lebanon Presbyterian Church was officially dissolved and replaced by the Noe Valley Ministry. Still home to a Presbyterian congregation, the Noe Valley Ministry soon evolved into de facto community cultural center for the neighborhood. The Noe Valley Nursery School, a cooperative effort started by a group of young Noe Valley mothers in 1969, moved into the Noe Valley Ministry facility. So too, did the offices of the neighborhood newspaper, the *Noe Valley Voice*, which started publishing in 1977.

Beginning in 1983, the Noe Valley Music Series has offered an eclectic and imaginative calendar of programs and performances at the Noe Valley Ministry. A decade later, the Noe Valley Chamber Music organization began its own series at the Sanchez Street location.

The oldest Catholic Church in Noe Valley, and the largest church to be located on Church Street in Noe Valley, St. Paul's was dedicated on May 29, 1911. St. Paul's Parish dates to 1880, and the original wood-frame church building was completed a year later under the direction of Fr. Lawrence Breslin.

Work on the present church began in 1897. The construction of the church took 14 years because the pastor, Rev. Michael Connolly, insisted that each phase of construction be paid for—through raffles and church bazaars—before moving on to the next. Indeed, most of the work was done on a voluntary basis by parishioners who were members of the building trades. On dedication day, Father Connolly wanted to know that the parish was not in debt from the massive undertaking, which had cost $250,000. In its report on the 1911 dedication, the *San Francisco Call* noted that 75 priests, 2 monsignors, and 4 bishops were in attendance.

Regarded as a masterpiece of American Gothic Revival architecture, the St. Paul's building was designed by architect Frank Shea, who did a great deal of memorable work in the ecclesiastical field. His other credits in San Francisco include St. James's, St. Brigid's, and the design of the Mission Dolores Basilica, which is adjacent to the original mission church. He also designed Holy Cross Church in Santa Cruz, where he also had a hand in reconstruction work following the 1906 earthquake.

The big twin-spired church facing Church Street at the corner of Valley Street was merely the centerpiece of the St. Paul's campus, which had a substantial presence at the southern end

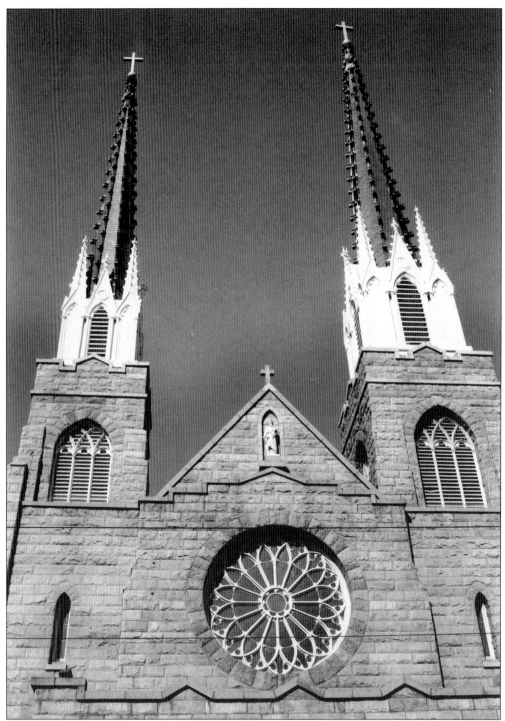

Pictured is the grand stone facade of St. Paul's Church and its famous spires. Like those of the great cathedral at Chartres in France, the spires are not identical in size. Extensive earthquake retrofit work done at the church in the wake of the 1989 earthquake was completed in time for Christmas Eve mass in 2000. (Photo by Bill Yenne.)

Constructed in 1881, the original St. Paul's Church was a neo-Gothic, wood-frame structure like the Lebanon Presbyterian Church. The parish would begin work on the larger, stone church 16 years later. (Courtesy of Mitchell Family Archives, via Karen Hanning.)

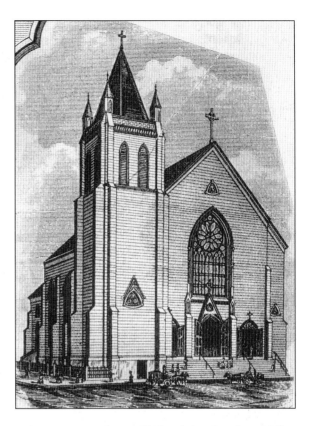

of Noe Valley for most of the 20th century. A convent was located behind the church on Valley Street, and, beginning in 1916, St. Paul's would open an archipelago of parish schools within a block's radius of the church. Elementary school facilities opened next door at Church and Twenty-ninth Streets and a block away at the corner of Valley and Sanchez Streets. The St. Paul's High School was located on Twenty-ninth Street between Church and Sanchez Streets.

By the latter quarter of the 20th century, as enrollment in schools city-wide declined, the high schools of the Archdiocese of San Francisco went through a consolidation period, and the high school at St. Paul's was closed.

When the Loma Prieta Earthquake struck San Francisco on October 17, 1989, St. Paul's Church survived with minimal damage, but the parish found itself in trouble. The school buildings were all rendered structurally unsafe, and the repairs and seismic retrofit work to them and to the church would be very costly. With the schools now closed indefinitely and the cost of upgrading the church estimated in the millions, the reaction of the archdiocese was to initiate plans to close the parish and to sell off the property—including the church building.

The St. Paul's parishioners, under the leadership of the Rev. Mario Farana, who became the pastor in 1993, rallied to the cause and raised the necessary money.

On the lighter side, St. Paul's had, in the meantime, been used in 1991 as the set for the film *Sister Act*, directed by Emile Ardolino and starring Whoopi Goldberg as a lounge singer placed in the witness protection program as a nun in a strict convent. On the set in lower Noe Valley were such other notable stars as Maggie Smith, who portrayed the Mother Superior, and Harvey Keitel. The church had also been used during the 1970s as the location for two episodes of the television series *Streets of San Francisco*, starring Michael Douglas.

The retrofit work at St. Paul's took several years, but it was completed in time for the Christmas Eve mass in 2000. An all-new St. Paul's elementary school was also built during this period, and it opened in 1999.

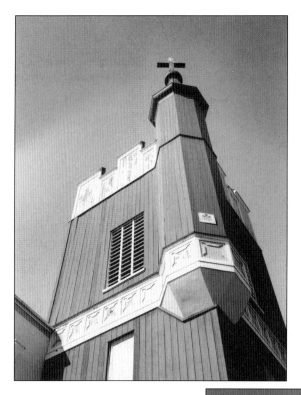

In 1907, work was completed on the building that would, after 1965, house the Bethany United Methodist Church. The church overlooks the corner of Clipper Street and Sanchez Street. It is just four blocks south of the Noe Valley Ministry, the former Lebanon Presbyterian Church. (Photo by Bill Yenne.)

The buildings adjacent to St. Paul's Church house the parish rectory as well as a novitiate of the Missionaries of Charity, the religious order founded by Mother Teresa. In 1982 she came here personally to open the facility, which is the only Missionaries of Charity novitiate in the United States. (Photo by Bill Yenne.)

In this photograph taken soon after the church's completion in 1911, the spires of St. Paul's Church are framed against the slopes of Billy Goat Hill in the distance. Much of the stone used in the construction of St. Paul's was quarried in these hills, just a few blocks away near Castro and Thirtieth Street. Granite was also salvaged from collapsed structures following the 1906 earthquake. (Courtesy of the Noe Valley Archives.)

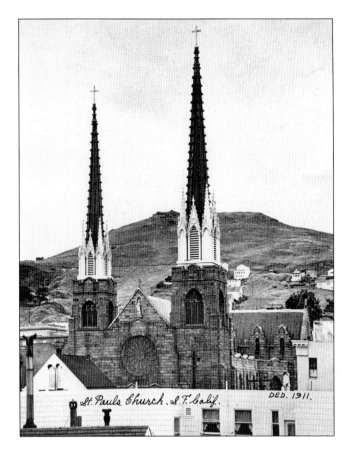

St. Pauls Church . S.F. Calif. DED. 1911.

At the opposite end of Noe Valley from St. Paul's is St. Philip the Apostle Church on Diamond Street at the corner of Elizabeth Street. With its large green shamrock on the sidewalk in front of the main entrance, St. Philip's has always been identified with its Irish roots. Indeed, through most of its history, the pastors have been Irish-born. The first pastor, the Reverend John Cullen, was born in Country Cavan, while the Reverend Michael Healy, the pastor at the beginning of the 21st century, was born in County Cork.

The parish was founded in 1910, with services held at a flat on Twenty-fourth Street about a block from the site of the present church. In 1912, a small "temporary" church was completed on Elizabeth Street to serve the young parish until money could be raised to build the present church. This church building was dedicated in 1925 by the Reverend John Cantillon of County Kerry, who would serve as pastor at St. Philip's from 1925 to 1951. In August 1938, St. Philip's dedicated its elementary school, which is still located adjacent to the church on Elizabeth Street.

St. Philip's is perhaps best known in Noe Valley for its annual festival, which is regarded by many as a Noe Valley "County Fair." Held annually on the last weekend of September, the St. Philip's Festival features games for all ages and live entertainment, as well as hot dogs and cotton candy.

A major architectural feature at St. Philip's is the bell tower that is located on the northwestern side of the church. The parish has an active bell-ringing organization that rings the church's big bronze bell on Sundays and special occasions. Known as the St. Philip's Belfry Society, the organization adopted the motto "Tintinnabulum noxia fugo," meaning that the ringing of bells gives flight to harmful things. Indeed, such a notion can be said to be an allegory for living in such a neighborhood as quiet, peaceful Noe Valley.

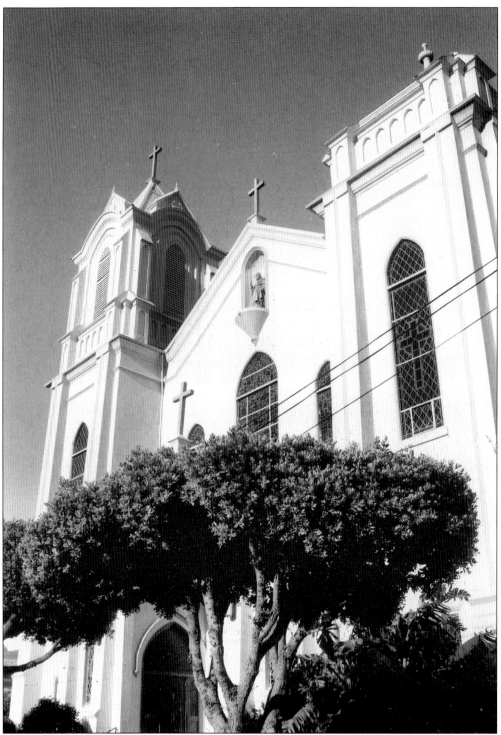

Dedicated on November 15, 1925, St. Philip the Apostle Church is located at the corner of Elizabeth Street and Diamond Street, anchoring the parish that comprises the northern part of Noe Valley. (Photo by Bill Yenne.)

The St. Philip the Apostle Parish School opened on August 7, 1938, with the first classes getting underway a month later. The driving force behind the school was Fr. John Cantillon, who was the parish's pastor from 1925 to 1951. A neighborhood school serving kindergartners through eighth-graders, it still draws most of its students from within Noe Valley, many from within walking distance. (Photo by Bill Yenne.)

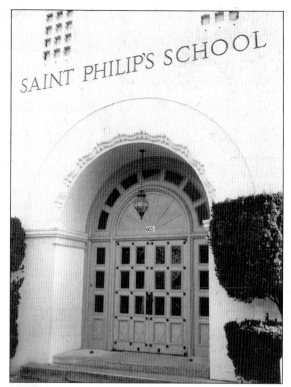

The main entrance to St. Philip the Apostle Church is bathed in late afternoon sunlight. (Photo by Bill Yenne.)

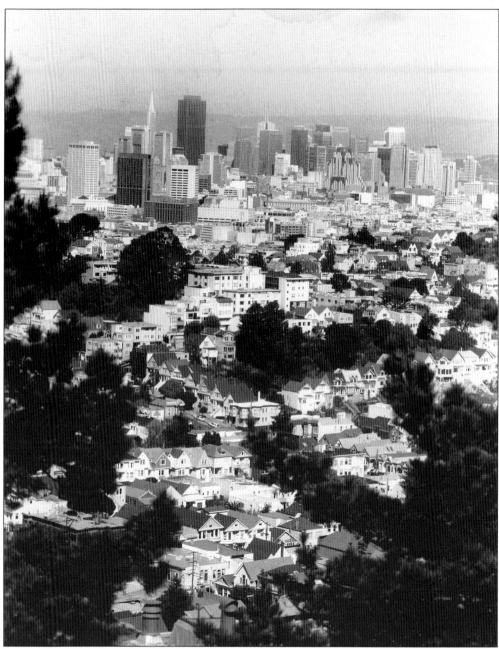

Known as the "village within the city," Noe Valley is a neighborhood of Victorian homes and small-town atmosphere located in the valley beyond the towering skyscrapers of downtown San Francisco. (Photo by Bill Yenne.)